GHOSTS OF OLD TOWN ALBUQUERQUE

CODY POLSTON

HAUNTED America

Published by Haunted America
A Division of The History Press
Charleston, SC 29403
www.historypress.net

First published 2012

Manufactured in the United States

ISBN 978.1.60949.662.3

Library of Congress Cataloging-in-Publication Data

Polston, Cody.
Ghosts of Old Town Albuquerque / Cody Polston.
pages cm
Includes bibliographical references.
ISBN 978-1-60949-662-3
1. Ghosts--New Mexico--Albuquerque--Anecdotes. 2. Haunted places--New Mexico-
-Albuquerque--Anecdotes. 3. Restaurants--New Mexico--Albuquerque--Anecdotes. 4.
Dwellings--New Mexico--Albuquerque--Anecdotes. 5. Old Town (Albuquerque, N.M.)-
-Social life and customs--Anecdotes. 6. Albuquerque (N.M.)--Social life and customs--
Anecdotes. 7. Old Town (Albuquerque, N.M.)--Biography--Anecdotes. 8. Albuquerque
(N.M.)--Biography--Anecdotes. 9. Old Town (Albuquerque, N.M.)--Buildings, structures,
etc.--Anecdotes. 10. Albuquerque (N.M.)--Buildings, structures, etc.--Anecdotes. I. Title.
BF1472.U6P663 2012
133.109789'61--dc23
2012029918

CONTENTS

INTRODUCTION

In 1985, I founded the Southwest Ghost Hunters Association (SGHA). Composed mostly of members of the military, we drifted together from one state to another until finally calling Albuquerque home. In 1997, there were only two known places in Old Town that had ghost stories associated with them: the Maria Teresa Restaurant and the Church Street Café. We had literally landed in virgin hunting grounds. Not only were we were the first ghost-hunting group in Albuquerque, we were the first in the state of New Mexico, and we quickly discovered a multitude of new haunted places, fascinating legends and urban legends.

Some of this has to do with the predominant cultures of the Land of Enchantment being a rich blend of Hispanic and Native American. Both of these cultures are highly respectful of the dead, and this itself has kept many of the haunted places concealed throughout the state. Stories may be told among friends and relatives, yet somehow they escaped the limelight. Of course, several of New Mexico's haunted places are quite famous, being featured on national television and written about in various books. However, it is important to understand that humans are storytellers by nature. This is why we have books, movies, magazines and television. Many of you have probably heard of the proverbial fishing story in which a fisherman catches a six-inch trout, but by the time the story is retold at the bar that night, the fish has become a fourteen-inch monster that snapped the line and got away. That degree of exaggeration is technically called myth building, and ghost stories are often subject to the same exaggerations. I have even witnessed this

with several of Albuquerque's own ghost stories. This is what makes ghost hunting and paranormal research (or whatever you wish to call it) difficult. How can you separate the myth from fact?

SGHA's research process is long and arduous, taking months and sometimes years to find an answer. We will conduct several investigations, explore the location's history and even have a skeptical analysis to attempt to explain the reported events. In many respects, we look at the stories and their locations as mysteries rather than as a haunting or something paranormal. Some mysteries can be solved and some cannot.

So, in this book, I am not only going to tell you most of the stories, I'm also going to reveal the results of SGHA's findings and my personal opinion of the reported paranormal activity at each location. To do this, I created a simple three-tiered rating system based on what has been solved and what is still, as of yet, unexplained:

Probable: A location or story with this rating still has too many unsolved variables to discount it as not being haunted. I have exhausted all of the resources available to me to date and have not found an explanation.

Improbable: A few mysteries remain, but the majority of this mystery has been solved. I do not believe this location could be haunted based on the present data. However, those few remaining mysteries are very interesting and may lend it the benefit of a doubt. Further investigation of these places could yield something that could move it up or down in the ratings.

Debunked: This mystery is just a story. I am very certain that the location isn't haunted or that the story is just an urban legend.

Due to the concerns of some of the witnesses involved, I have changed the names of certain individuals. As diverse and unique as the hauntings included here are, they have one particular thing in common. These hauntings occur and recur in specific places. They are somehow linked to the site or location where they were witnessed.

For several years, SGHA conducted guided tours in Old Town as a fundraiser. Eventually, the tours became so popular that we created a business, New Mexico Ghost Tours. We tried our best to keep the integrity of the tour, adding and removing locations annually as more information became available. As such, the original ghost tour of Old Town was constantly changing as we investigated and learned more about its obscure history. As

a result, Old Town is one of the most researched areas of Albuquerque for ghost investigations. Since 1998, we have had just over one hundred investigations in this section of the city alone.

By 2006, another company had taken over the tours, and we ceased doing tours altogether as we felt it created a conflict of interest with the research aspect of our organization. The locations in Old Town are known because SGHA investigated them and created the ghost tour of Old Town. Though we no longer conduct the tours or affiliate with the company that does, you will see photos and hear audio on ghost tours that SGHA collected years ago to this day.

Although our investigative process has debunked several locations, the history and locations that have unsolved elements are quite fascinating in their own right. All but two of the locations in this book are within walking distance of the Old Town Plaza, and I have marked them on a map located before the second chapter. I have also included some of the notes and stories from the original tour, as well as some observations about the locations themselves. Enjoy!

CHAPTER 1

THE HISTORY OF THE DUKE CITY

The ancestral Pueblo natives were the area's first permanent occupants, probably arriving in the sixth century. They planted corn, beans and squash and constructed adobe and brick pit homes along the banks of the Rio Grande. They ultimately disappeared from the region in about AD 1300.

Albuquerque is a magnificently unique combination of the very old and highly contemporary nature, the manmade environment, the frontier town and the cosmopolitan city. It is a harmonious and spectacular combination of extremely diverse cultures, cuisines, people, styles, stories, pursuits and panoramas. It is a city with a rich history, as evidence of inhabitation dates back as long as twenty-five thousand years. That is the estimated age of bones recovered from a cave in the northwestern sector of the Sandia Mountains in 1936.

Anasazi Indians were the next to settle in the area. They lived here for two centuries, from AD 1100 to 1300, and established several communities throughout northwestern New Mexico that were connected by sophisticated transportation and communication networks.

In 1540, the Spanish arrived. Explorer-conquistador Francisco Vásquez de Coronado came north from Mexico in search of the mythical seven cities of Cibola. He—along with his entourage of troops, priests and beasts—is believed to have spent the winter of that year in an Indian pueblo on the west bank of the Rio Grande twenty miles north of Albuquerque. Coronado eventually left, but Spanish settlers began arriving in greater numbers. This

was one of the factors eventually leading to the Pueblo Revolt of 1680. In that year, Pueblo natives overthrew the Spaniards, who had occupied their lands for more than eighty years. Since 1598, Don Juan de Oñate y Salazar brought a small group of colonists into the mesa and canyon country of northern New Mexico, and as a result, Spain asserted its sovereignty over the Pueblo people. Spanish officials demanded that Pueblos pay tribute to the Spanish Crown by working for encomenderos, a small number of privileged Spaniards to whom Spanish officials entrusted the Pueblos and their labor. At the same time, Spanish priests established missions in the Pueblos' farming villages and demanded that the natives abandon their religion in favor of Christianity. The Pueblo natives, who vastly outnumbered their Spanish overlords, tolerated this arrangement for several generations.

Finally, in the late summer of 1680, the Pueblos destroyed the Spanish colony of New Mexico. Coordinating their efforts, they launched a well-planned surprise attack. From the kiva at Taos, Pueblo messengers secretly carried calendars in the form of knotted cords to participating pueblos. Each knot marked a day until the Pueblos would take up arms. The last knot was to be untied on August 11, but the rebellion exploded a day early. Tipped off by sympathetic Pueblos, Spaniards captured two of the rebel messengers on August 9.

When leaders of the revolt learned that they had been betrayed, they moved the attack up a day. Despite the warning, the revolt caught Spaniards off-guard. They could not imagine the magnitude of the planned assault. Scattered in isolated farms and ranches along the Rio Grande and its tributaries, Spaniards were easy prey for the rebels. It was estimated that the Pueblos killed more than four hundred of New Mexico's Hispanic residents, whose total numbers did not exceed three thousand. The rebels desecrated the churches and killed twenty-one of the province's thirty-three Franciscans, in many cases humiliating, tormenting and beating them before taking their lives.

At the time of the revolt, there were more Spanish people living on farms and ranches along the river around present-day Albuquerque than there were in Santa Fe, and about 120 Spanish settlers were killed there. Spanish survivors were driven as far south as present-day El Paso. For the next twelve years, New Mexico remained free of Spanish rule, but eventually the Spanish settlers returned. By the seventeenth century, it was sufficiently populated to have acquired a name, Bosque Grande de San Francisco Xavier. A "bosque" is a forest on the banks of a river or other body of water, or simply an area of thick vegetation.

In 1706, the ambitious provisional governor of the territory, Don Francisco Cuervo y Valdez, petitioned the Spanish government for permission to establish the bosque as a formal villa. The Spanish required a minimum of thirty families in an area to establish a villa. However, Cuervo had only eighteen in Bosque Grande. But Cuervo was a shrewd politician, and he came up with a plan that he felt gave him a good chance of acceptance. Basically, he exaggerated the truth and raised the number of families living in the area. Additionally, he made an interesting offer to the man who was responsible for preliminary approval of his application, Viceroy Francisco Fernandez de la Cueva, the Duke of Alburquerque.

In his application, Cuervo declared that he wanted to establish the villa in the name of the Duke and call it Alburquerque. The petition was accepted, and thus was born the city of Alburquerque. The first "r" in the original name was later dropped. Legend has it that a sign painter for the railroad omitted it either accidentally or because he didn't have enough room for the whole name. Another possible origin of the city's name comes from the Latin translation of Alburquerque, which means "white oak." Alburquerque, Spain, has a large number of white oak trees and thus was given the appropriate name. However, it is likely that the "r" fell out of use casually over a long period, probably given that it is nearly inaudible when spoken.

The original church collapsed in 1792. Governor Fernando de la Concho ordered every Albuquerque family to donate either money or labor to rebuild it. In 1793, they began San Felipe de Neri Church on the north side of the plaza where it remains to this day.

In 1846, the United States government claimed the territory for its own. The Civil War touched the city briefly when Confederate troops occupied Albuquerque. Once the war had passed, Anglo settlers, who had been slow to move in before, began showing a much greater interest and began arriving in large numbers.

A view of what Old Town Albuquerque was like can be found in the memoirs of Mrs. Heacock, the wife of one of city's infamous judges:

Before the coming of the railroad, there was nothing very effective in the way of law or law enforcement. There was a great deal of stealing, especially horse thieving, and sometimes shooting. People had to take the law into their own hands, and thieves were strung up on the tree nearest to the place where they were caught more often than not.

One night, about 1890, she thought, she was just clearing away the supper table when she heard shots outside. She ran to the door to see what

was happening, when her husband called her back. The safest thing to do at such times was to lie down on the floor. The drunken cowboys generally had no desire to kill anyone, but it was safer to keep out of the way of their bullets. On one occasion, a cowboy had killed a child. He was drunk and looking for black cats to shoot. He was horrified when he realized what he had done, but they hanged him. They had to make an example of someone in order to make Albuquerque safe for their children.

Mr. Heacock had prosecuted the case and was so upset when the man was hanged that he refused thereafter to serve except as a defense lawyer.

Another time, Billy the Kid came to the door to get her husband to help him out of some kind of a scrape. Mrs. Heacock answered the door. She said that he looked like any nice young lad to her. Afterward, everyone was talking about him, and she was glad that she'd seen him, but she didn't ever believe any of that talk about his being a bad character. "They were after him, and he had to protect himself, didn't he?"

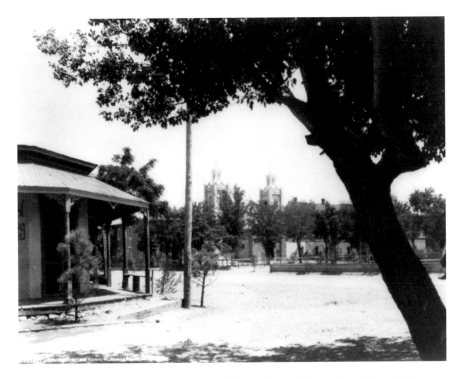

The southwest corner of Old Town Plaza, looking northeast. *Courtesy of the Library of Congress.*

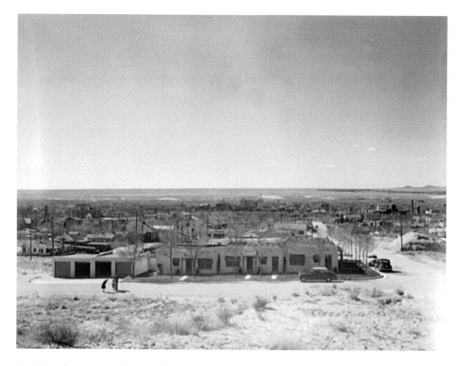

Looking west toward the city of Albuquerque, 1900. *Courtesy of the Library of Congress.*

Another resident of the 1800s, Mrs. Fergusson, recalled Mexican girls passing by dressed in bright calico and "slat" sunbonnets, the same kind the covered wagon women wore. Their mothers were always wrapped in black shawls. She remembers hearing her father tell of seeing the Penitentes whipping themselves with cactus whips in the Old Town Plaza, though she herself never saw them until years later and then with more difficulty in an out-of-the-way Mexican village.

An octagonal adobe house once stood in the middle of the plaza. In it dwelt the barber, a big fat man named Brown. Barber Brown was also the town's lone dentist. Whenever anyone suffered from toothache, the barber was called and pulled the tooth. On top of the octagonal house was a flagpole and in the yard a cannon. It was the barber's duty to raise the flag and shoot off the cannon every Fourth of July.

In the 1880s, sheriffs were chosen in quite an unusual manner. Perfecto Armijo and Santiago Baca took turns serving as peace officer. When it was time to "elect" a sheriff, they would collect their toughest friends, meet in a

vacant lot and do battle with sticks, rocks, gun butts and fists. Judge William Heacock was the referee. A crowd gathered to watch, and the onlookers voted for the winner.

One of the city's most influential forces, the railroad, arrived in 1880. Las Vegas, Santa Fe and other New Mexico towns fell victim to the piratical practices of the railroad barons, but Albuquerque welcomed the iron horse with open arms, hearts and wallets, as well as a two-hundred-foot-wide right-of-way. With the railroad came sober, solid businessmen. They intended to have safe respectable homes for their wives and children and an environment that would appeal to homebuilders, and before many years, Albuquerque had become a comparatively peaceful place. After the coming of the railroad, there was even more lawlessness for a while, but within a few years, things quieted down here, and the outlaws moved on to wilder places.

Albuquerque's racy past compares with Dodge City or Tombstone. The railroad brought new consumer goods and undesirables, including gamblers and the first prostitutes. In the late 1800s, the city had twenty saloons, multiple gambling houses and brothels. The red-light district flourished along Third and Fourth Streets between Copper and Tijeras. Train robberies and gunfights were not uncommon, and most citizens carried pistols. Vigilantes hanged many outlaws and horse thieves. In the 1880s, Albuquerque also had opium dens. There were campaigns held not to close them but rather to move them off Central Avenue, which was called Railroad Avenue back then, to Gold or Silver.

The impact of the railroad brought changes to the prevailing architecture of the city. Perhaps most important, the railroad was responsible for a drastic alteration of the ethnic makeup of the city. By 1881, the population of Albuquerque was one thousand. One legend says that Billy the Kid traveled to Albuquerque because of a tale that was spread around the town. Supposedly, a local hardware store owner had made several claims about what he would do should Billy the Kid ever have the misfortune to step into his hardware store. Billy strutted into the hardware store and walked out with a plow, while the storeowner hid under a wagon somewhere near the site of the present YMCA.

Within a few years, Albuquerque had become predominantly Anglo in population, and in 1885, it was incorporated as a town. In 1889, Albuquerque won the rather heated battle for the right to locate the state university in the city. By 1891, the population of Albuquerque had grown to four thousand. The town had twenty saloons and two banks, one of which went broke during the panic of 1893. The city also had as many as twenty-four gambling

establishments. People were moving to Albuquerque for reasons of health, and the city was taking on many aspects of larger eastern cities. Even after the 1900s, there were still occasional stage holdups, and by 1903, there had been two cases of school money embezzling by the city's officials. Oddly enough, Old Town, the original town site, was not incorporated into the city of Albuquerque until 1950.

As the new Albuquerque flourished, the railroad assigned Colonel Marmon to lay out some city streets. He laid one street parallel to the horsecar line that he called Central, and the first road west of the tracks and running parallel he named First. Although the railroad did not request any roads east of the tracks, this was where Marmon plotted his widest street. He named that street Broadway and proceeded to develop four streets east of it. He named the first street Arno, after Arno Huning, who was a pioneer businessman in Albuquerque. The next two streets he named after his own children, Edith and Walter, and his last street was named High.

The mighty Rio Grande has also played a significant role in Albuquerque's history and landscape. In its early days, floods with each spring rising from

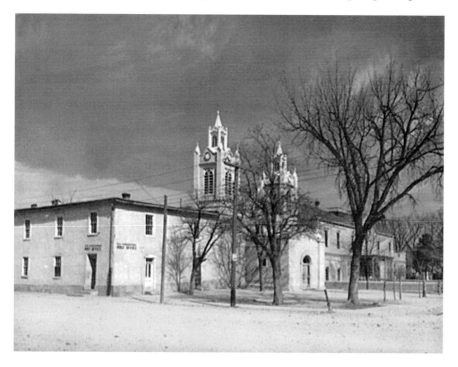

The San Felipe de Neri Church in the Old Town Plaza in 1940. *Courtesy of the Library of Congress.*

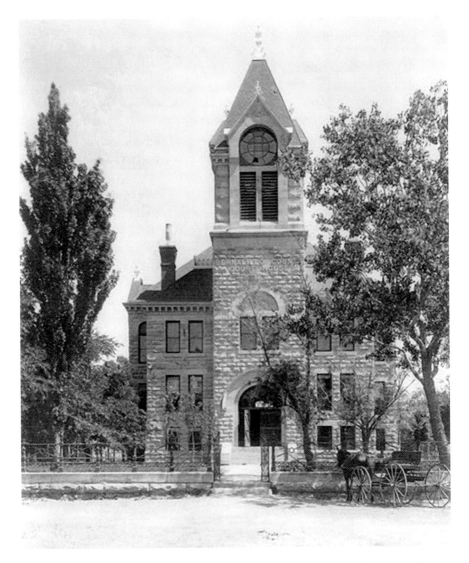

The original county courthouse in Old Town before it was torn down and moved to New Town. *Courtesy of the Library of Congress.*

the Rio Grande menaced portions of the city. Melting snow in the Colorado Mountains, together with spring rains, caused the river to reach flood stage. High water formerly flooded all the low-lying areas in the river bottoms near the city. In early days, the Rio Grande had a habit of choosing a new course almost at will. Breaking through its banks upstream, the river often chose a new path southward, sometimes passing through the center of the town.

During a devastating flood on May 28, 1874, the Rio Grande overflowed its banks and surrounded Old Town, making Albuquerque temporarily an island. At another time, the river (or a part of it) flowed along where the railroad tracks are now laid. Eastward, cloudbursts and heavy rains in the mountains often sent flash floods pouring down into the lower levels, bringing enormous amounts of silt and earth from higher points. So while the Rio Grande invariably carried away much topsoil, the mountain floods generally replaced it with rich loam from the mountain areas. The citizens were not surprised when, in 1885, a survey showed that the streets were some three inches higher than when first laid out a few years before. The mountain floods were as beneficent as the Rio's were destructive, the former more than offsetting the latter.

In later years, corrective measures were taken to deepen and straighten the Rio Grande to force it to cut its own channel and cease making trouble each spring when on rampage. Storm sewers, diversion canals and other means removed all danger from both the river and the freshets, which come rushing down from the Sandias with each heavy rain in the highlands.

Old Town Albuquerque was once more Victorian and less New Mexican. After being joined to Albuquerque in the 1950s, it became a tourist magnet. Merchants altered façades, added second stories, built new buildings and "puebloized" existing buildings to conform to visitors' expectations.

As one of North America's oldest cities—rich in a history of conquest, conflict, religion, business and violent death—it is not surprising that Albuquerque also has so many interesting ghost stories.

Map of locations, corresponding to the chapters in this book.

CHAPTER 2

THE BOTTGER MANSION

110 San Felipe Street

The construction of the Bottger Mansion was started in 1905 and completed within two years. The residence is located half a block from Albuquerque's historic plaza, where Albuquerque's heritage began in 1706. Charles Bottger was a wool exporter originally from Germany who made his fortune after immigrating to New Jersey. He moved to New Mexico to be close to the Native American sheep ranchers and their wool supply. There were four original mansions in Old Town, and only the Bottger remains, intact, virtually as it was when built. Charles Bottger also owned a saloon west of the mansion (now the parking lot) and a toll bridge over the Rio Grande. His saloon advertised "Fine Whiskeys, Fine Cigars, Fine Women and Billiards."

The mansion was used as living quarters by three generations of Bottgers and then sold several times. During the 1940s, it was used as a home for a small colony of Buddhists. Later, it featured a restaurant downstairs and a boarding house and beauty salon upstairs.

Throughout the years, the mansion has also had its share of famous visitors. In 1955, a young Elvis Presley, along with Bill Black and Scotty Moore, performed two shows in Albuquerque and stayed at the Bottger, leaving the next day for a show in Amarillo.

In the late 1950s, a prominent Italian family rented the Bottger Mansion for a large wedding. Frank Sinatra was a guest, and he performed in the

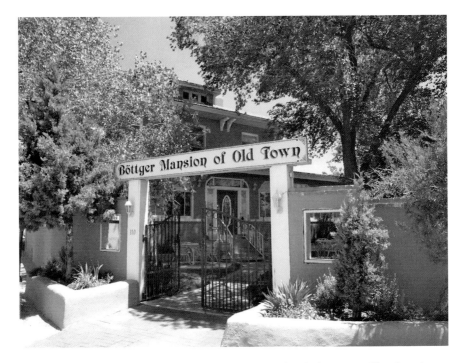

The portal to the Bottger Mansion, one of Old Town's historical treasures. *Photo by author.*

courtyard after the wedding dinner was served. In the 1940s, the Federal Bureau of Investigation's most wanted criminal, Machine Gun Kelly, was being hunted by lawmen everywhere. Kelly, his girlfriend and his gang were headed back to Memphis from California and checked into the Bottger under assumed names. They had dyed their hair and purchased new clothes to help conceal their identities. After several days, the owners became suspicious when they noticed that the group always sent a neighborhood boy out to purchase the meals and bring them back to the Bottger for consumption in the rooms. They decided to notify the police but were overheard by one of the gang members. The gang quickly left, just ahead of the law. However, they were captured shortly thereafter and imprisoned.

As far as paranormal activity goes, the mansion has a nice variety of unexplainable phenomena, including strange sounds, cold spots, mysterious smells and even an apparition or two. Yvonne Koch, a previous owner, confessed that she feels the ghosts more often than seeing them. She believes that there are six spirits at the mansion, including a native woman

who fell down the stairs to her death, as well as Charles and Miquela Bottger. The Bottgers' daughter, Dorothy, is also believed to still be hanging around, having died from pneumonia after being locked out of the house. She is most often heard in the Linda Lee and the Carole Rose Suites. No one has ever reported seeing her, but many, many guests report hearing her sigh from time to time. Some believe that she is Charles's granddaughter, who died as a very old lady and lamented the fact that her children intended to sell the property after her death. Could she also be responsible for the cold spots that have been felt by numerous guests

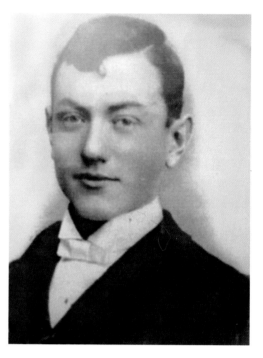

Charles Bottger in his youth. *Photo by author.*

while sitting in the chair in the lobby? At the mansion, she is referred to as the "Grandma Ghost."

The "Lover Ghost" and the spirit of Charles Bottger are two other spirits that inhabit the mansion. One morning, a guest at the luxurious lodge came down from her room holding several pieces of a broken soap dish in her hands. The rattled guest swore that she didn't break it, claiming instead that it went flying across the bathroom and crashed into the opposite wall. Not an unusual occurrence for that room, as the toilet lid in the downstairs bathroom has been known to move. The objects on top of it fly off and scatter across the room, leaving an occasional mess.

The southeastern room on the second floor, named Stephanie Lynn, seems to be one of the most active. One guest reported a "white fog" that came under the door and tried to enter her mouth. Other guests have reported the feeling of an unseen person breathing on their arms. The Lover Ghost reportedly joins young, pretty women in the bedrooms at night. There are several stories about his past visits in which he just wants to lie down next to the young ladies. When they turn on the light to see who has joined them,

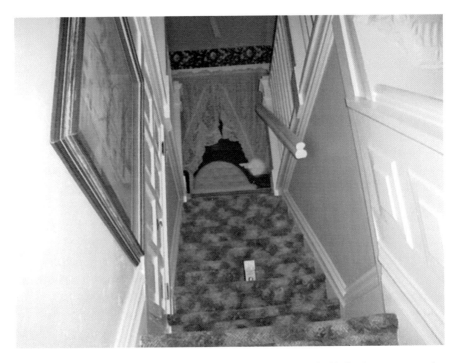

The stairs leading to the second floor. The small door on the left side leads to an unused staircase that exits the western portion of the house. The stairs are concealed today. *Photo by author.*

no one is there. However, it also seems that a female ghost likes that room as well. One customer of the bed-and-breakfast e-mailed me, detailing the events that happened to her one evening:

> *I was sound asleep, laying flat on my back. I actually felt it before I saw it. Before opening my eyes, I was aware that someone was lying on top of me, and whoever this person was, they were quite heavy. For a split second, the moment before I opened my eyes, I thought that perhaps my brother had managed to sneak into my room and was trying to scare me. Then, after a few blinks, I saw it, a woman, completely white from head to toe. I could see her white hair floating about her. She was somehow ghastly. I can't explain it really; she just was. I was overwhelmed with fear; I had to, needed to, wanted to scream! I opened my mouth to draw in breath. I felt my lungs empty, like I had fallen on my back and the wind was forced out. I could not scream because she had sucked the life breath from me. Then the weight began to lift, first from my chest, then midsection. I began to gasp*

for air, starring wide-eyed at her face. Finally, she completely raised herself off of me, and then…she smiled. I will never get the picture out of my mind, the most horrid smile, and a look of satisfaction. She was gone. As soon as fear had subsided enough for my breath and my speech to return, I did scream!

I sat awake for several hours, convincing myself that it was nothing more than a nightmare, but I never did go back to sleep.

Another story, occurring in the same room, seems to have similar elements:

Both my younger sister and I heard somebody walking around the house, both on the stairs to the second floor, as well as the stairs to the basement. During our stay over the weekend, we both had rooms on the second floor. We never actually heard anything on the ground floor, just on the staircases to upper floor. One night, I was lying in my bed trying to get to sleep. My sister had a room directly opposite of my own. Just after midnight, I heard the door across the hall open, followed by the sound of footsteps. Shortly thereafter, I heard the door to my room open. Since we were the only people staying at the Bed and Breakfast, I left the door unlocked. I then heard the very distinctive sound of footsteps on the floor as it always creaked slightly when anybody walked across it. I assumed that my younger sister had a nightmare or something and had come into my room to sleep as she had done many times in the past. I heard five or six footsteps and then nothing. I waited and waited, fully expecting her to say something to me along the lines of, "I can't sleep" or "Can I sleep in here?"

Nothing came. I finally rolled over and saw somebody dressed in a flowing white gown standing about 12 feet from my bedside. I have poor eyesight, and at the time wore glasses. I still assumed this to be my sister and said something to the effect of, "What? You can't sleep? You can stay in here if you want to."

I then waited, but the person said nothing to me and just stood there. I thought that my sister was sleepwalking, so I rolled over again. I waited about a minute, and then rolled back over, and there was nobody there. I heard no footsteps leaving the room, so I got out of bed, walked across the hall to my sister's room, and found her sound asleep in her bed. Stranger still, she was not wearing anything even remotely close to what the figure I saw in my room had been wearing.

That was when I realized that I had just seen a ghost. Needless to say, I did not sleep very much the rest of the night.

There is a great deal of speculation concerning who this particular spirit is. Many believe that it is the ghost of Charles Bottger himself.

The Garcia family purchased the Bottger and converted it to a B&B in the 1980s. They did a great business for many years before selling it to the Koch family in 1997. The Kochs changed the name to the Bottger-Koch Mansion during their ownership.

The current owners, Gary and Carole Millhollon, purchased it from the Kochs in 2003 and reverted to the original, historic name. Gary and Carole have also had encounters with Charles's ghost. One evening, they were staying in the mansion in an upstairs bedroom. This particular night, Carole, who is a light sleeper, was having trouble getting to sleep because footsteps could be heard walking back and forth across the wooden floor of the downstairs parlor. So Carole went downstairs and told the spirit, "Dammit, Charles, if you don't stop pacing and let me get some sleep, we are going to have a priest here tomorrow, and we are going to exorcize you!" The noises quickly ceased.

Charles's ghost has also been known to be quite helpful as well. One hot September day, one of the guests wanted a window opened upstairs that had been painted over. The guest tried to open it, as did Carole, neither having any success. Finally, Carole asked aloud, "Come on, Charles. Help me open the window." She tried again, and the window opened with ease. However, it freaked the guest out, and he wanted to change rooms afterward. Other sightings of ghosts have occurred in the rooms that now compose the wine cellar. A typical example of this occurred to a woman named Mary who was staying in one of the rooms with her husband John:

> Late that evening I was suddenly awoken from a deep sleep. I glanced over at the corner of my room and saw what I thought was a woman crouched down, with her head buried in her hands. I have never heard such anguish coming from anyone in my entire life. It was dark in my room, so all I could see was a solid black silhouette. It looked like smoke; at least that is the best way I can describe it. I raised my head up, and after a few more seconds, grabbed my husband's arm, trying to wake him up. I was terrified at the presence of this stranger in our room.
>
> I wanted to wake my husband who was sleeping next to me, but I couldn't move because I was so afraid. I simply couldn't move. I was so afraid that it was going to attack me that I tried to scream. Yet nothing came out. The only thing I could do was clamp my eyes closed, so I did. When I opened them up again a few minutes later, it was gone. I didn't

get out of bed; instead, I lay there until I fell asleep. Needless to say, I did not sleep well that night, so I was the first one up in the morning. I questioned everyone in the mansion about it that morning when they got up; all said that they had slept soundly and never got out of bed. I never really mentioned it again, but I now question whether the whole experience was a dream, but only one fact keeps me from thinking so is that I never went to sleep until after it was all over with.

Rating: Improbable

The most curious incident that I have personally experienced in the mansion occurred during my first investigation of the building. We had set up a Trifield meter on the stairs leading to the second floor. The Trifield is so sensitive that it can actually detect the movement of air. I staked out the location from the bottom of the stairs with a comrade, both of us armed with cameras. After several hours, we suddenly heard footsteps coming from the second floor—odd, especially since there was no one staying up there that night. As we listened to the footsteps, the Trifield meter suddenly went off. We quickly raised our cameras and took several photographs of the stairway, but nothing unusual was photographed. After several more investigations, we still have not found anything out of the ordinary.

There are several reasons why I give the Bottger an improbable rating. The first is that most of the witness stories can easily be explained by several medical possibilities, such as sleep paralysis, or by the sheer lack of any form of data that would indicate that something paranormal is occurring here. During our first investigation, the former owners unscrewed a light bulb in the basement hallway so that it would flicker when we went by. Is fraud a major catalyst of the earlier reports?

The building was also equipped with an early form of an intercom called speaking tubes. Constructed out of brass tubes, one could call through one end and be clearly heard on another floor. These devices are still in place but have been covered over, making the transmission of "unexplainable" noises quite easy.

Guests have also reported feeling cold spots, especially when sitting in the chair in the lobby, and the feeling of an unseen person breathing on their arms. I was able to replicate both of these events, and they are simply effects created by the natural movement of air through the building.

There are also contradictions in the story of the Grandma Ghost. Depending on which side of the family you ask, the ghost is either Dorothy

or an uncle who simply got drunk and passed out on the stairs outside, thus dying from hypothermia.

As with many haunted locations, some of the eyewitness encounters cannot be fully replicated, yet there are sufficient explanations to account for the majority of the paranormal phenomena.

CURIOSITIES

Halfway up the stairs, you'll notice a very small doorway. It leads to an unused staircase that exits the western portion of the house. The stairs are concealed. Just outside on the northern end of the mansion is the carriage house, where Charles kept his new automobile.

LA PLACITA RESTAURANT

CASA DE ARMIJO

208 San Felipe Street

Walking around Old Town Albuquerque, one is surrounded by the ancient history of the Duke City. One of the most obvious historical structures is a block-long building, painted white, with a pitched roof covering its second story. Located on the corner of South Plaza and San Felipe Street, it is the home of the La Placita Restaurant, formerly known as Don Ambrosia Armijo's store and home. Casa de Armijo, the actual house, is now a set of shops back behind the restaurant called the Patio Market.

The Ambrosio Armijo House was built between 1880 and 1882 of adobe as a store and house complex. It originally consisted of two square-shaped buildings with pitched and gabled roofs joined by a small structure or passageway in the center. The Sanborn insurance maps of 1891 and 1931 show that the building has undergone several renovations, additions and razings over the years according to the functions that the building was serving at the time. In the beginning, the store was connected by a frame walkway to Casa de Armijo. When the northwestern portion of Casa de Armijo was razed or collapsed, the two buildings became more independent.

At one time, the store had a New Albuquerque–style wooden false front that is clearly visible in photographs taken in 1879. Casa de Armijo was designed in the classic placita (little plaza) style, developed for defense against raiding by nomadic Native Americans.

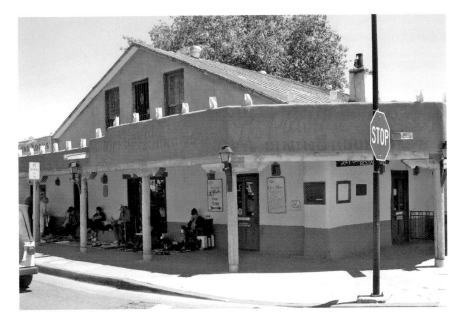

Casa de Armijo, now the La Placita Restaurant. *Photo by author.*

Between 1908 and 1924, the southwest extensions of Casa de Armijo had either fallen into ruins or been razed. The 1931 map shows only the west and south sides of the original structure remaining. The current northeast and east sides of the building are additions or restorations made in the 1940s.

The 1872 New Mexico territorial ordinance required county commissioners to function as a school board, and Ambrosio Armijo lent the use of the existing south wing of Casa de Armijo for use as a school building for five years until a permanent school was built.

According to Old Town lore, the walnut staircase and the tiny, nonfunctional second story of the store were built for the wedding of his daughter, Teresa, to Dr. John Symington of Maryland. It seems that Teresa had a beautiful wedding gown with a long train that could not be suitably displayed in any available building. Rather than displease his daughter, Ambrosio ordered a beautiful staircase long enough to display the gown and built the room at the top of the stairs so that she could make a grand entrance down the stairs and across the plaza to the church for the marriage ceremony.

The zaguan (carriage way) leading to the present-day shops at the rear of the restaurant bears the date of 1855 and was the center for tourism back in the 1950s.

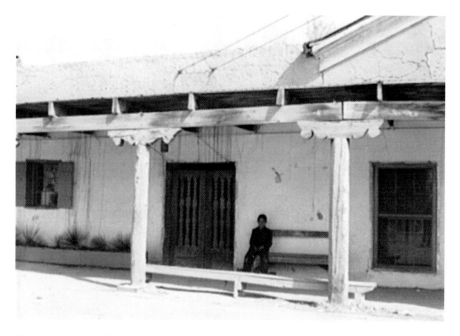

Casa de Armijo in 1940. *Courtesy of the Library of Congress.*

This photo, taken in 1940, shows the zaguan in the far right of the photograph. *Courtesy of the Library of Congress.*

Nelda Sewell bought the decaying and partially ruined Casa de Armijo in 1930. Back then, the building was known as the Don Ambrosia Armijo store and home. With the help of some friends, Matt Pearce and Bill Lumpkins, they restored the old building and converted several of the rooms into studio apartments. A portion of it was opened as a restaurant in about 1935 and was run by a couple of University of New Mexico alums named Schaeffer and Rogers.

In 1939, the restaurant closed its doors and was once again put up for sale. It was reopened again in 1940 and grew from the original one-room operation until it eventually took over the entire Casa de Armijo.

The Casa de Armijo is purportedly haunted by at least four different ghosts, although there could be several others. The first is the spirit of a little girl known as Elizabeth. It is believed that she was a servant girl who died from tuberculosis in about 1783. Witnesses have often described her as being "cute as a button." She has long black hair and always appears wearing

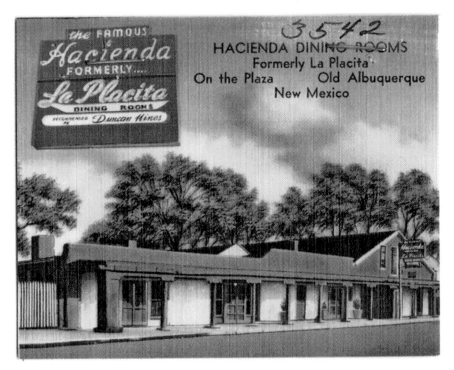

This postcard illustrates one of the confusing elements of documenting ghost sightings. La Placita was once called La Hacienda, and a restaurant with that same name now exists next door. While old records document ghostly tales, which La Hacienda are they referring to? *Courtesy of the Library of Congress.*

a beautiful white dress, speculated by many as being a communion dress. Decorated with fancy beadwork about the neck and shoulders, the dress is often the feature that stands out when people see her. It just seems to be out of place.

When Elizabeth appears, she is not quite what one would expect from watching movies and television shows about ghosts. She is not translucent or glowing. She appears just like a solid person, looking like an average, everyday child—that is, until she does something unusual like run through a wall or suddenly vanish.

Over the years, it has also been discovered that Elizabeth is most likely to appear in front of other children or the elderly. Although she has been sighted in various locations throughout the entire restaurant, one of her favorite places to appear is in the mirror of the women's restroom. The women's restroom was once a part of Elizabeth's bedroom, the other half being composed of a studio belonging to La Placita's resident artist. Needless to say, it is quite unnerving to see the little girl's reflection in the mirror and not see her anywhere else in the room.

On one occasion, there was a wedding reception held at the restaurant when two women noticed a cute little girl sitting by herself in a corner table. When one of them got up to ask her who her parents were, the girl jumped out of her chair and ran away down the hallway and back toward the restrooms. Being concerned for the girl's welfare, the women went looking for her, but after a thorough search, they were unable to locate her. However, they were not thinking ghost so much as lost little girl. They began wandering around the restaurant, asking some of the patrons if they had seen the little girl.

Eventually, their actions caught the eye of the manager, who approached them and asked them what they were looking for. They told him about the lost little girl and described her to him. The manager's reply, which he is quite used to by now, was, "Don't worry. That's just one of our resident ghosts."

At her mischievous best, Elizabeth likes to pull on the long skirts of some of the waitresses and patrons, but she has learned a few scary tricks over the years. The following account was told to one of the tour guides of the Old Town ghost walk:

> *After hanging out at the plaza's gazebo, we moved underneath the portal of La Placita's Restaurant. One of my friends started telling stories about how the building was haunted by the ghost of a little girl. I really didn't believe him, and we started debating about the existence of ghosts. The*

argument got a little heated as my friend took my skepticism badly, that I was calling him a liar.

After about 15 minutes or so, my girlfriend shouted, "Oh my God!"

I turned around to see a hideous girl climbing up the window (on the actual glass pane) sneering. I quickly turned away from the window but not before I got a good look at her. She was dressed in white pajamas, and her face was all distorted. It reminded of that little girl in the movie "The Exorcist." I have never been so scared in my life. Most of the people I was with ran off, but my girlfriend was excited about it. She kept saying, "It was her, the ghost of the little girl!"

She really wanted to go back and look for her in the window, but she wouldn't go by herself. She kept asking me to go with her.

I would have nothing to do it however, so we went back to the car to leave. I was parked on South Plaza Street and to leave, we had to pass by the window at the Restaurant. As I turned left onto San Felipe, we both saw a woman standing in the window, watching us. I'm not sure if it was a ghost or not, she didn't look scary or anything. But the building was dark and no one appeared to be inside, no one alive anyway.

Elizabeth has repeated this performance in front of the Old Town ghost tour on at least one occasion. On June 12, 2004, she startled a group of eight tourists on the tour by jumping up and climbing up the window into the ceiling. Her appearance was just as gruesome as the previous sighting, and all but two of the tourists fled. The remaining two were so excited about seeing a ghost that they refused to leave the area for several hours, hoping to catch a glimpse of the phantom girl.

Another resident spirit of this historic hacienda, called George, has become adept at flustering the restaurant's wait staff by mimicking voices. One of his favorite tricks is to close in behind a waiter or waitress and softly call their name. To their dismay, they would turn around to discover that no one else was in the room with them. Eventually, George learned how to imitate the manager's voice, sending the wait staff scurrying around the building in search of the boss. If this wasn't enough mischief, he also prefers to use his little tricks around shift changes, causing quite a bit of commotion in the process.

Another rather sociable ghost has also been reported throughout various locations in the building. Many believe that it is Ambrosia's daughter, Victoriana. Victoriana was born in 1849 and died on October 6, 1867, at the tender age of eighteen. She was married to Jose Ynez Perea, and it is

Unusual image captured in La Placita's main hallway. *Courtesy of SGHA.*

speculated that she died of complications during childbirth. Since Teresa didn't marry young, it's safe to say that they wouldn't have rushed another daughter to the altar, especially considering their wealth. They didn't need to marry anyone off for familial survival.

In all of the sightings of this apparition, she has never been seen alone. Most often, when she is seen, she will be with Elizabeth. She seems to favor the main hallway that contains the antique stairs that were imported from Spain. Other speculation suggests that she is Teresa since the stairs were erected for her. She has also been sighted, once again with Elizabeth, in the center dining room of the restaurant. This area was once the placita or patio of the hacienda. Today, one can still see the old shade tree that graces the area. The owners had the roof built around it when it was enclosed, preserving that piece of history.

Another ghost seen at the La Placita was reported by one of the security guards who patrols Old Town at night. South Plaza Street lines up directly with a large window in the building, giving a view of one of the major hallways of the building. This hall contains the entrances to the restrooms and the artist's gallery (Elizabeth's room), as well as provides a good view of the antique staircase.

A 35mm photograph taken in the main dining room in 2001 during an investigation of the building. *Courtesy of SGHA.*

One night, the security guard was out doing his rounds when he turned onto South Plaza Street. As his headlights illuminated the hallway through the window, he saw something unusual and pulled over to investigate. Unable to determine exactly what he saw, he decided to come in the next morning to talk to the manager about it. The next day, he asked the manager if he was renting out any part of the building. The manager's reply was, "No, it's a restaurant. We are not renting any part of it out to tenants. Why do you ask?" The security guard then told him of his patrol the previous night. "As I was approaching your building last night around 2:30 a.m., I noticed a woman holding a baby in your hallway. She looked directly at me and then moved off to another portion of the building. I got out of the car to look for her, but I was unable to see her again through any of the windows. None of the alarms had gone off, so I figured that she belonged inside. I just wanted to check with you to make sure."

The manager once again informed him that no areas of the building were being rented out to anyone and that no one would have been inside that early in the morning. When asked what the woman looked like, the security guard moved inside the artist's gallery and pointed to a mural on the north wall: "She looked almost exactly like the third figure in this mural."

Rating: Plausible

The La Placita Restaurant is the first stop on the ghost tour that runs through Old Town Albuquerque in the evenings. One night, I was leading one of the tours for a group of thirteen girls and eight adults. For some reason, I decided to run the tour in reverse that night, so La Placita actually became the last stop. It was close to midnight as I stood by the large window that faces directly toward South Plaza Street. My back was toward the window as I began to tell the guests in the group some of the stories of the building; suddenly, all of the girls screamed. The sudden barrage of sound temporarily stunned me, but as I looked around and into the window, I could see a large cloud of smoke slowly fading away. It was positioned just past the staircase, near the entrance to Elizabeth's old room. The restaurant had been closed for quite some time, and the building was dark. I turned back around and asked the guests on the tour what they had seen. They described Elizabeth in complete detail; it was unusual, as I had not gotten to any of the stories about her yet.

According to my guests, a little girl in a white dress had been seated in a small chair at the end of the hallway. Because she appeared to be "solid," they assumed that she must be the daughter of an employee and ignored her. After a few minutes, she got up and walked down the hallway toward the group. When she reached the area by the stairs, she turned and vanished, dissolving into what appeared to be a cloud of smoke.

Sightings like this remained a mystery for many years until it was finally replicated by SHIELD, SGHA's skeptical arm, and the Arizona Ghost Hunters in 2004. The effect was caused by truck lights striking the glass of the old window. As the vehicles turned off Rio Grande Street toward the building, the reflected light would travel up the window. What made the illusion so convincing is that the reflected light would form patterns that resembled the outline of a small person in shape. The patterns themselves were caused by the degradation of the surface of the glass. This occurs naturally by weathering and the chemicals used to clean it. Over time, this can stain the surface of the glass.

The translucent stains on the window were illuminated by the headlights, and as it traveled up the window, it created a rather eerie effect. After watching the illusion replicated several times, I can easily understand how someone could believe it was a ghost. This effect no longer occurs due to an employee attempting to pull a prank on the guests of the tour in 2005. Waiting behind the curtains on the right side of the window he was planning to hit the glass at the right time during the telling of the buildings' ghost story to startle the

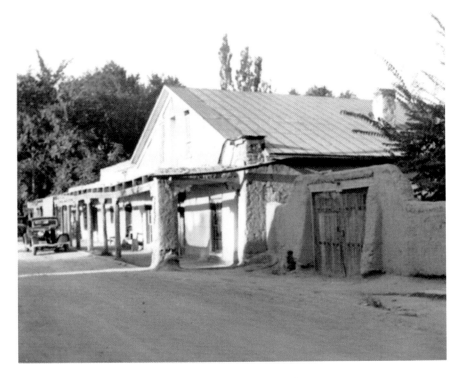

Casa de Armijo in the early 1900s. *Courtesy of the Library of Congress.*

tourists. Unfortunately, he hit the glass too hard and ended up breaking it. It has since been completely replaced, and the effect no longer occurs due to the newer glass. Despite this, there are still several compelling things that suggest that something unusual is going on inside the building.

The first is Elizabeth's dress. Often it is the standout feature that catches the attention of the witnesses. It is a communion dress that is elaborately decorated with beadwork, especially around the neck, shoulders and hem, where there are certain designs. One of SGHA's longest-held secrets is exactly what those designs are. Those familiar with designs that are sacred to the Pueblo natives would see a sun wheel. Those who are not would probably incorrectly identify them as swastikas. Two large ones are on the shoulders, and a multitude of them adorn the hem.

Over the years, we have received dozens of comments on the tour and e-mails to SGHA about the "Nazi Mexican girl" inside La Placita. These reports are from people all over the world who have never met one another,

yet they describe the dress in the same way. Before this book, the designs of the dress have never been made public. So how are all of these people seeing exactly the same thing? While some of them have reported paranormal experiences, there are a surprising number of them that have not. It was simply a curiosity. This was the reason SGHA chose to keep the details of the dress secretive. If someone reported seeing the "ghost," we just had to ask for the description of her dress, and we would know if they had experienced the same phenomena as so many others. Because of this, I am still going to keep the colors of the designs confidential.

The other thing that gives this location a plausible rating is the results of an experiment that SGHA was engaged in twelve years ago. We were curious if positive ions could somehow affect "haunted" locations and obtained several high-powered positive ion generators. The experiment was conducted at fourteen locations throughout the Southwest, and in only two locations, La Placita being one of them, did we obtain interesting results. Visible only in an infrared camera focused on the staircase, the investigators from SGHA and the restaurant staff who were working that night watched as several bright flashes of light appeared, moved and then disappeared around the stairs. Eventually, we were able to identify the point source at the top of the staircase, but we were never able to figure out exactly what caused the lights. While there is no direct evidence to prove that this was paranormal, the strangeness of it lends the validity of the haunting the benefit of the doubt.

George is most active around shift changes and after closing. He does not seem to favor any particular rooms and has been "heard" throughout various locations in the restaurant. Elizabeth has most often been spotted in the main hall, near the staircase and in the mirror in the women's restroom. Oddly enough, the hallway is also the most likely place to see Victoriana, making it the hotspot of the building.

CURIOSITIES

Be sure to check out the antique stairs and the living tree in La Placitas' main dining room. All of the glass windows that look into the main dining room were once exterior windows looking into the placita of the building. Another interesting piece of history can be seen if you leave the restaurant and go back around the corner to the Patio Market. This was the location of the original casa.

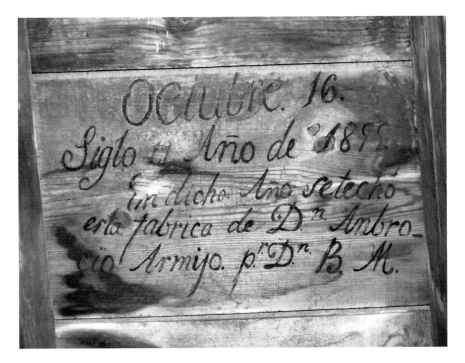

The zaguan beam leading to the Patio Market contains an engraving that dates this section of the building to 1895. *Photo by author.*

The second you enter the zaguan (carriage way) leading to the present-day shops at the rear, look up at the ceiling. You will see the inscription in the wooden beams that was carved by the man who built the house, as well as the date it was finished, 1855.

Updates: Those of you who may have gone on the ghost tour in Old Town or have read my other book, Haunted New Mexico, the Ghosts of Albuquerque, *will notice a slight variance of the names of the ghosts. The original names for the specters that haunt La Placita came from a psychic who had visited the building about seven years before the ghost tours began. When SGHA began researching the building, members obtained two electronic voice phenomena (EVP) samples that had the names Victoria and Elizabeth in them. It appeared that the psychic was correct in revealing the names of the ghosts. So, the ghosts were named appropriately. Over the years, more research has been done into the history of the home, and it was discovered that one of Ambrosia's daughters was named Victoriana. Apparently, the names that had been given to the ghosts were incorrect, so the names were switched around to correct the error.*

CHAPTER 4
LA PIÑATA

2 Patio Market Street

L a Piñata is a small shop located in the Casa de Armijo patio, now known as the Patio Market. This was a regular stop on the first version of the Old Town ghost tour, but it was eventually taken off when the tour time was moved up and the patio was closed behind a locked gate. The original location of the site would have been the stable areas of Casa de Armijo. However, it is believed that the original building once housed a small school as well. The school would have been in operation in the early 1900s. It became a private residence in 1942 and eventually became a shop in 1947.

This location is supposedly haunted by the ghost of a hungry little boy. It is believed that the boy still lingers in the former school. There may have been other spirits at the location, including one that was violent, but the building was "cleansed" at least once. The ghost moves around the dolls in the shop, and piñatas have been found on the floor in areas too far away to have just fallen down. Another interesting event that has occurred concerns a candy bowl. The candy was left in a bowl on the counter for the "little boy." The bowl was full when the owner left one night but half full when she opened up the next day.

The most interesting story concerns the "violent ghost," which, according to the owner, attacked her in the back storeroom. She was on a ladder trying to put some boxes on an upper shelf when something grabbed the ladder and starting shaking it, trying to make her fall off. She eventually got off the ladder and fled to the front, where that particular spirit refused

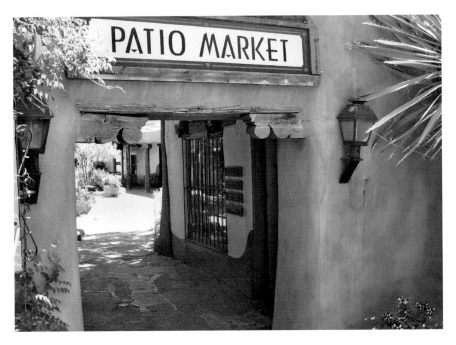

The La Piñata, located just inside the Patio Market. At one time, this building served as one of Albuquerque's first schools. *Photo by author.*

to go. She believes that there was something in the backroom; religious symbols in the main part of the store kept the evil spirit contained back there. There were other incidents in the past but nothing as violent as this encounter. She contacted a local shaman and had him cleanse the building. Since then, the back room has had no activity.

Rating: Improbable
In recent years the reported activity of this location has dramatically decreased. We picked up several odd electromagnetic fields: one in the bathroom, where problems with the lighting have occurred; one in the back storeroom, where "something" knocked the owner of the shop off a ladder; and one in the area near the back of the store. These fields are often associated with older electrical wiring.

We set up a Trifield meter in the rear of the shop and backed off to monitor any changes in the magnetic field of the area. The Trifield did sound an alarm several times, lasting several seconds with each incident; however, we later discovered that the source of this reading was probably a ham radio signal.

THE BLUEHER MANSION

At the heart of this district is the original central plaza that is lined with more than one hundred quaint little shops. Like everything else in Albuquerque, a visit to Old Town is a delightful mix of old and new, with sights that range from Civil War cannons to the San Felipe de Neri Church. Just off the main plaza, the La Hacienda Restaurant preserves the core of what once was a large Italianate-style brick home constructed in 1898.

A very old adobe structure, it was rented out by the army for use as officers' quarters and later housed the first Albuquerque Academy in 1879. It was razed before construction of the Blueher house began. The Blueher Mansion was once a two-story Queen Anne brick mansion, one of the four large homes that graced the plaza before World War I. The interior of the house featured pine woodwork stained to simulate oak, a magnificent staircase to the second story, etched glass door panels, stenciled room wall trim and a large upstairs linen closet. Servants were able to reach the second story via their own steep staircase in the rear of the building.

During the puebloization of the 1950s, the Blueher house was adapted for restaurant purposes by the removal of the high hipped roof, porches and wings. Adobe walls were added, and stucco was applied over the brickwork. A man named Herman Blueher, who arrived in Albuquerque in about 1882, constructed the house with his wife, Sophie. The architectural style had become less popular on the East Coast but arrived simultaneously with earlier and later styles with the railroad. Herman got a job working for a local produce farmer, and over the years, he gradually learned the

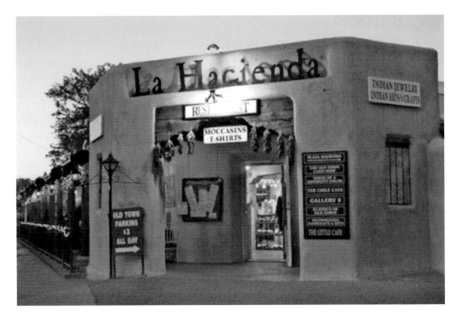

La Hacienda, once the Blueher Mansion. *Photo by author.*

operational aspects of the farm and produce business. By 1898, he had amassed a considerable fortune and went into business for himself.

Blueher's market garden was more than twenty acres in extent and had an unusual irrigation pond in the center near the northwest edge of what is now Tiguex Park. The pond was stocked with fish, and according to Old Town folklore, residents would occasionally ice skate on the frozen pond in the winter.

Blueher's business was also the first farm equipment dealership in Albuquerque that introduced draft horses to the city and experimented with the cultivation of tobacco in the Rio Grande Valley. Later, the house was the home of Dr. Nolting's family, until its later remodeling into the Hacienda dining rooms. Leon Watson added the new layout of the building, an addition that wrapped around the mansion itself, sometime before 1953.

In 1954, the building changed ownership again. The Brown family, owners of the La Placita Restaurant next door, decided to relocate their restaurant to a larger locale. They renamed the restaurant La Hacienda, and during its peak years, it was the largest and busiest restaurant in Albuquerque. Many celebrities of the day dined there, including Claude Rains, Duncan Hines and Gene Tierney.

The present-day haunting at the restaurant seems to have begun sometime after the brick addition was installed. Disembodied voices are often associated with the antique staircase that occupies the center of the old mansion. One evening, the manager was talking to a pair of customers when they all heard a burst of laughter that seemed to originate from the third floor. This was most unusual, as the third floor is sealed off to the general public by a gateway built onto the actual stairs themselves. Assuming that a group of people had bypassed the gate and were wandering around upstairs, the manager went up to chase them back downstairs. When he arrived, he thoroughly searched the entire third floor but was unable to find anyone.

After his search, the manager was still uncertain about the source of the laughter, so he located the customers he had been talking with earlier and asked them about it. They agreed that the laughter was definitely coming from the third floor. The phenomenon associated with the stairs works both ways as well. Late one night, long after the restaurant had closed, a former manager and employee were up in the employee break room, located on the third floor, unwinding after a long day's work. As they conversed, one of them suddenly noticed an unusual sound coming from the stairway. After listening for a few seconds, they both went over the stairs, where they could distinctly hear the faint sounds of a piano and the muffled conversation of a crowd of people. Knowing that they were the only ones inside the building, they cautiously went down the stairs to discover who or what was inside the building.

When they arrived on the first floor, they discovered that all of the lights were out and the room was completely empty. Stranger still, it was completely quiet. So, they shrugged it off and went back upstairs. As they approached the third floor, they once again heard the piano playing, along with the distant sounds of conversation. Quickly, they ran back down the stairs to once again discover that the room was empty. Having enough of the mysterious voices for one night, they gathered their personal effects and left for the night, leaving the building to the ghosts.

Another waitress, whom I will call Maria, has worked at the restaurant for about three years. During that time, she has witnessed several bizarre things—ashtrays being turned upside down, doors opening, music playing, the sound of footsteps walking up behind her and dishes being tossed about. Some employees hear their names being called out when no one is around them, and an apparition of a woman has been seen by two of the restaurant's employees. On one occasion, the ghost even sent one of Maria's coworkers running out the door. She explained the noise as hard,

heavy, footsteps running right at her. She had been very skeptical until this happened to her. "I named our ghost Jose. I always say goodnight to him when I close at night."

Another interesting story about the restaurant happened to a couple of customers late one November evening. When they walked in, the waitress greeted them while she was cleaning up a table and asked them to take any table they wanted while she finished her task. The restaurant was empty, and they were the only patrons at that particular time. A little while after they sat down, she came to their table with three glasses of water plus three sets of silverware. "Where's the boy?" she asked them.

"What boy?" was the husband's reply.

"The little boy that came in with you into the restaurant?" she asked. The couple looked at each other, knowing the answer, or at least thinking they did. Is the restaurant itself haunted, or was the waitress just plain nuts?

The oldest-known ghost story of the La Hacienda Restaurant comes from a woman named Frances and was recorded by the Works Progress Administration (WPA) during a series of interviews that it did in Old Town. Here is her account of what happened:

> *It happened in 1958, on a Tuesday in February at about 6 in the morning. I had just gotten to work at the restaurant, and I was about to put on a pot of coffee. When you come through the main door, it's a straight shot, more or less, to the coffee pot and about five feet to the table where we sit and have our coffee before starting work. The other waitress had not gotten to work yet, so I was alone in the building except for the cook. As I started toward the coffee pot, I saw a cup on the table. I walked up to it and noticed that the cup contained coffee probably left there from the previous night. I was going to dump it out, but when I touched the coffee with my finger, to my surprise it was hot. Thinking it was just a coincidence, I reached to pick up the cup, and when I touched it, the outside of the cup was ice cold.*
>
> *At that time, Luis, the cook, entered the building, so leaving the cup on the table, I went over to the door and called to him, "Come over here and see this"; however, when we reached the table where the cup had been, it was gone. Stranger still, Luis insisted that he did not have any coffee that morning and I was making the first pot of the day. I haven't had any more experiences like this and I hope I never do.*

"There's always some sort of presence here," said the cook of several years. He believes that there are two or three ghosts here, including a gentleman

who may be the ghost of a Spanish soldier who served and died here. He is always watchful but never hostile.

Another waitress reported seeing something in the kitchen doorway, feeling someone standing there, and one time she caught a glimpse of a girl disappear into the second-floor storage room, only to find the room empty when she looked. Many visitors have also reported seeing, hearing and feeling the presence of ghosts. One is thought to be the ghost of Mary, who had worked in the gift shop and restaurant in about 1980. She was dating a local gangster when one day she decided to drop him and move on with her life. The boyfriend was outraged and showed up at the restaurant's back door later that night. Banging on the door, he demanded to see Mary. The kitchen staff immediately called the police and sent a runner to the gift shop to inform Mary that her boyfriend was outside and violently upset. Tragically, before the runner reached the gift shop, Mary clocked out and left the building, exiting out the rear door. The irate boyfriend spotted her and shot her two times with a .38 special before shooting himself. They died together by the old tree behind the building.

After her death, customers of the restaurant reported seeing the ghost of the dead girl around the building, as if she was still cleaning and serving drinks, just as she had done when she was alive. Throughout the years, many people have seen Mary and have also seen their drinks move around their table while dining at the restaurant. Mary is also known to pull people's hair, and sometimes people find fresh water rise up around the table while they are eating, as if someone had just cleaned their table with a dishrag.

A former waitress named Amanda said that she was closing one night when lights started "flickering" on the second floor. When she went to investigate, she looked in a mirror, and to her horror, the reflection wasn't hers but that of an old person. Needless to say, she ran for it. "It scared me. The whole thing was just so eerie," she said.

Photo taken on the second floor during an investigation. *Photo by author.*

There were many reports of a woman in a flowing, white, old-fashioned dress that could walk through walls. The apparition, thought to be Sophie Blueher, always brought about feelings of not only peace and tranquility but also sadness. Workmen also reported a figure of a man in old-fashioned dress who would stand at the top of the main staircase. At times, the sound of children crying could be heard from the second floor. One employee who worked in the gift shop often heard the sound of footsteps and furniture scraping the floor above her head. At first, she gave no thought to the sounds and assumed that someone lived on the second floor. It was several months after she had quit before she discovered the second floor was unoccupied.

Another older account of the building being haunted comes from the year 1960. A carpenter named Ruben was working late one night alone on the third floor, removing old paint from the window frames with a hammer, chisel and screwdriver. Every time he would set his tools down and turn his back, he would find his tools hung up on the wall several feet away. Occasionally, he also would smell a faint fragrance of perfume or flowers

The rear of the restaurant, showing the remnants of the old mansion. The hipped roof was removed during the puebloization of Old Town. *Photo by author.*

after his tools had been moved. He eventually was able to tell where his tools were located by simply following his nose.

The walking ghost tour of Old Town has also had several sightings of unusual lights originating from the third floor. As the tour comes around the corner from Blueher's barn, people see either a faint white or red glow coming from the upper-left window of the old house. The light seems to flicker for a few moments and then disappear.

One lucky tour group had the privilege of seeing the light "manifest" into the apparition of a middle-aged woman. She was wearing a white Victorian dress and appeared to be watching the tour as it approached. The apparition lasted several seconds before it vanished, but not before fifteen tourists got a good look at her. Several of the tourists attempted to take photographs of her, but the flash from their cameras reflected off the glass, obscuring whatever might have been on the other side of the window.

Rating: Plausible to Improbable

This one is really hard to judge. There are recorded historical accounts, and I have had a personal experience here myself. Yet there have also been many things that have been explained, including a possible hoax.

My personal experience occurred late one evening. I was up on the third floor with a former manger. It was after hours, and the building was empty and locked up. As we were talking, we distinctly heard the sounds of a group of people having a conversation, along with the faint sound of a piano. The sounds were definitely coming from the first floor of the mansion, so we ran down the stairs to see who was inside. When we arrived on the first floor, it was completely quiet. We then went back upstairs and heard the same noises coming from below. So once again, we headed back downstairs, again finding the room to be completely quiet. It seems that the spirits do not like it when someone crashes their party.

The red glow seen in the second-floor window was eventually discovered to be nothing more than a laser pointer that was carried by a tour guide.

The apparition itself turned out to be a waitress at the restaurant who had gone upstairs to get a few supplies from storage. She told me sometime later that the flashing of so many cameras at once practically blinded her for several minutes. She now waits until the tour has passed before going upstairs.

CHAPTER 6

THE BLUEHER BARN

Plaza Hacienda

The large building in the Plaza Hacienda was Blueher's barn. According to legend, this was the place where lovers went for romantic rendezvous and is the site of a romance that ended in murder.

The legend notes that a daughter of the Armijo family was engaged to be wed to a local man who apparently was something of a Romeo. One evening, she became restless and wandered out for a stroll to ease her mind. When she reached the barn, she spied her beloved in the arms of another woman. Enraged, she grabbed a hatchet that was hung up on the side of the barn and confronted her cheating fiancée. By the time she reached him, she was in a blind rage. This was a location well known in town as a place for lovers. If he was here with another woman, it was likely that a large portion of the townsfolk knew, and she was humiliated by the thought of it.

She brutally attacked him, swinging the hatchet until all of the rage had left her body. With her fiancée dismembered, she turned to the other woman, who was fleeing for her life. According to the story, she got away, but Armijo's daughter permanently lost her sanity. It is not known what happened to her afterward, but her ghost now haunts the area behind the barn. She is called the Hatchet Lady. She wields a bloody hatchet, and her eyes are black, as if they were made out of coal. It is said that she attacks lovers who get too close to the barn, forever living in the darkness due to her sins.

This was one of the stories that the Travel Channel filmed for its series called *Weird Travels*. However, there are several important pieces of information that ended up on the editing room floor. First of all, both Bob (SGHA's co-founder) and I explicitly stated that the story is nothing more

The area near Blueher's barn is now called the Hacienda Plaza. *Photo by author.*

than a myth. In fact, we tried to talk the Travel Channel out of filming that location and choosing another because of this. While there is evidence that a man was attacked with a garden hoe behind the Blueher barn and that it was a domestic dispute, there is no evidence of a murder taking place there. The story eventually became a distorted myth. After Lizzie Borden did her thing, the garden hoe was turned into a hatchet. Honeymoon Row used to be near this area, so it became a folktale that men would tell their sweethearts. It is not haunted. It never was.

From further historical research, we now know that the family names presented in the Travel Channel's episode are incorrect. The Armijos were a prominent family, and if the myth were true, there would have been something recorded in the media sources at the time. There is nothing except for a blurb about the garden hoe assault. It is also important to note that there are a lot of Hatchet Ladies out there. It is a very popular myth. Part of the problem with the ghost tour is that the guides who actually interviewed witnesses and did the research are no longer there, and their knowledge went with them. As I have already stated, it's a myth; no one actually sees anything. The part about the black eyes is probably an exaggeration like the hatchet, a creation to make the story spookier. However, I will give you some more information on how I learned the details of the legend.

I was doing a tour one night in 2003. On the tour was an elderly gentleman in his nineties (I think his name was Sherman). I had just finished the Hatchet Lady story when he remarked that I had forgotten the part about the bloody handprint. Curious, I asked him what he was referring to.

He said that he was raised in Old Town and was familiar with the Hatchet Lady story. However, he remembers a slightly different angle to it. Back then, the Hatchet Lady did not run around attacking lovers. In fact, she was often a bearer of warnings. If a couple really wanted to see if their relationship was bound for a good marriage, they would go to Honeymoon Row, near the rear of the barn. Once there, they would recite her name nine times. On the ninth time, she would appear behind the couple. If the marriage was going to be successful, she would leave a bloody handprint on the back of the girl as a warning for her to keep an eye on her future husband. If it was doomed, she would scratch the back of the boys. If nothing happened, then the outcome of the marriage was uncertain. There was just one rule, however. The couple could not turn around or they would be cursed by the Hatchet Lady.

Sherman remembered this well as one evening, when he was twelve years old, his older brother paid him a nickel (a lot of money back then) to hide out behind the barn with a leather work glove and a gallon of red paint. His brother was bringing his sweetheart, and when they were in position, Sherman was supposed to sneak up and apply the "bloody handprint" on the back of his brother's girlfriend. After waiting for what seemed to be hours, Sherman was about to give up when he turned around to find a goat's head right in his face. He screamed and ran. Of course, he did admit that it was probably just a goat that had escaped its pen, but back then, he was really frightened by it. Realizing that I had a direct source for the myth, I pressed Sherman for details. He told me that people described her as wearing a white bloody dress with eyes that were solid black (because she had no soul).

She was also thought to be a bruja (witch) and could shape-shift into several animal forms—this may explain why he got frightened by the goat and how she could curse the couples that turned to look at her.

Rating: Debunked/Urban Legend

The Hatchet Lady is a common urban legend, with variants all over the United States. There is a Hatchet Lady at Buie Park in Stamford, Texas; one in Moon Point Cemetery in Illinois; one in Arbor Hill in Albany, New York; and yet another around the Red Rocks, Colorado area. These examples are only a few of the ones that are out there.

THE GARCIA HOUSE (CAFÉ AU LAIT)

C afé au Lait occupies what was once part of the Garcia House. It was built by Nick Garcia for wife Pauline and family in the early 1900s. The café occupies the northern half of the building. The surrounding buildings date back more than two hundred years.

The Garcias' ancestors first arrived in Albuquerque in 1706. The Sunflower emblem on the building front is the Garcia trademark and can be seen on adobe homes throughout the city. Nick Garcia was a social man who enjoyed late evenings spent playing Three-Card Monte with his closest friends. Today, the house is located at the back of the Poco a Poco Patio in Old Town. It is surrounded by a variety of other shops and businesses.

Unexplainable noises, including disembodied voices, can be heard coming from the area near the stairs and the rooms directly above. Disembodied footsteps have also been heard coming down the eastern balcony, moving south to north.

Several of the unusual occurrences are centered on the kitchen area. One Saturday afternoon, the cook, Dora, was in the kitchen, and grease had gotten all over the kitchen floor. She was trying to get to the sink and couldn't because she kept slipping on the grease. She made one final attempt to make it to the sink but slipped and fell backward. However, instead of hitting the ground, invisible hands caught her in midair, lifted her to an upright position and held on until she could get her balance. Other odd occurrences in the kitchen include pots and dishes being moved about in the dead of night, leaving the kitchen in disarray. The manager has shown me

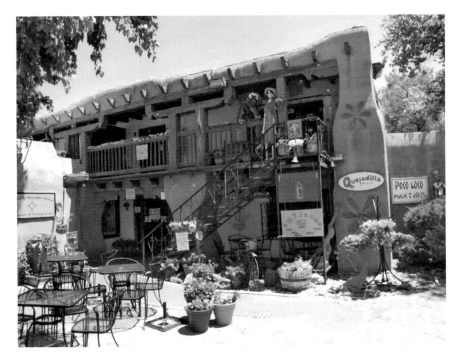

The Garcia House in the Poco Apoco Patio. *Photo by author.*

where the cookware was found in relation to the location where it was kept. The distances are too great for the pots to have just fallen onto the floor. In some instances, they had been moved as far as ten feet and around corners of appliances.

Occasionally, on Saturday evenings, female employees would also feel a presence come up behind them in the kitchen, and some invisible force would pull on their apron strings. If there are ghosts at this location, they seem to be mischievous but harmless.

The sound of laughing has been heard coming from the balcony when the building is empty except for the witnesses. When the source of the laughing is investigated, the sounds stop completely. Objects are also reported to move by themselves at this location. Several people believe that the ghost of Mr. Garcia and his friends are the causes of the laughter and other odd phenomena.

The restaurant's staff members are not the only ones who have had unusual encounters. One Saturday night, the security guard, Ed, was checking on the patio when he heard roars of laughter coming from upstairs, and he saw a

An unusual black shadow captured on film during an investigation of the building. *Photo by author.*

light on in the upstairs window. People are not usually there so late at night, so the guard went upstairs to check it out. When he got to the top of the stairs, it was pitch dark, with no light anywhere, and the building was locked up tight with no one there.

This building was also another stop on the early version of the Old Town ghost tour. The tenants at that time ran an antique and clothing store on the second floor. They also experienced disembodied voices, often talking in Spanish, and had objects moved around in their shop. In particular, objects such as replica guns and clothing were often discovered to have been relocated from their displays and placed in various spots around the shop.

At one point, it got so bad that a walk-around was added to the process of opening up to locate out-of-place items and return them to their proper places.

Rating: Plausible to Improbable

This is another one that is difficult to rate. There are just too many experiences that have occurred to various tenants of the building over the years. What makes this particularly odd is that the building is not a well-known haunt, and new tenants are not told about the site's history of unusual occurrences. Yet they have all eventually experienced the same kind of phenomena.

However, investigations by SGHA have never yielded anything that would suggest that it has paranormal activity occurring. The only hypothesis that I could replicate was the story of the security guard and the patio phenomena. We were able to prove that loud voices in the adjacent parking lot, located to the southeast of the building, could easily echo into the patio area. When standing at the front gate, the source of the voices seemed to originate from the café.

THE CHURCH STREET CAFÉ

CASA DE RUIZ

2111 Church Street Northwest

Walking throughout the narrow streets of Albuquerque's Old Town Plaza, the smell of New Mexico will entice your senses with green chiles and spices. One of the renowned restaurants in Old Town resides on a quaint street tucked behind the San Felipe de Neri Church. It is appropriately called the Church Street Café, being located on this street. The quality of the food served will more than appease the hungry passerby, as well as keep the ethereal inhabitants of the household proud. From time to time, the permanent inhabitants of the premise make their presence known to both owners and patrons alike.

Casa de Ruiz is said to have been built soon after the founding of Old Town in 1706. The building was a U-shaped hacienda-style residence made of terrones adobe bricks, more than two feet thick in some places. At that time, the area was a marshy swamp due to the frequent flooding of the Rio Grande.

The first written record of the Ruiz family dates to 1834, but it is believed that several generations had already lived in the home by that time. The building remained the Ruiz family home until the last resident, Rufina G. Ruiz, passed away in 1991 at the age of ninety-one. The road was originally called School Street.

After being vacant for a short time, the residence was sold to Marie Coleman, who renovated the Ruiz's home into the very relaxing and homey

The Church Street Café, the ancestral home of the Ruiz family. *Photo by author.*

This old family photo still hangs in the building. Sarah is the second person from the left. The photo was taken in front of the house before renovations.

café. Since her arrival at the Casa de Ruiz, Marie Coleman and all others who grace its steps know that there is something special about this place. Others have had much more direct experience than just a "feeling" to confirm their suspicions. It is the belief of the current café's owner that the individual that dwells within the walls of the old structure is a previous dona of the Casa de Ruiz named Sarah.

Sarah Ruiz was born more than a century before the idea of the Church Street Café was even conceived. Her life held many passions and talents that made her a unique woman in her time. As a curandera, a Mexican healer said to have dabbled in healing herbs and other realms of mysticism, she never married, even though there were many passionate love affairs in her life, one leaving her with a lovely daughter, Rufina. The nature of a strong Mexican family is to not let what belongs to them go easily, and so they remain within their walls to ensure that no one forgets that the Church Street Café will always remain apart of the Ruiz family.

Ms. Coleman's first introduction to Sarah began during the remodeling process of the hacienda. At the time of Marie's purchase of the property, the walls had begun to collapse, weakened mainly by the flood that had occurred in 1920. The entire west wing of the hacienda was completely destroyed, but Marie's concern was for the existing east section. If a roof was not put over the interior adobe walls soon, further collapses would have been likely.

Marie's first experience occurred when she was walking through the building with a contractor. As they entered the old hacienda, a distinct female voice shouted at her from behind. The voice was absolutely insistent that Marie remove the contractor from the property. She continued to feel anger rising about her as she rushed the man from room to room. The atmosphere of the building became much more pleasant as soon as the man was out the door.

Several years later, Marie learned that the contractor she had rushed out of her café was the grandson of one of Sarah Ruiz's love affairs that did not end quite so well.

Early in her life, Sarah became pregnant. When she confronted her lover about the pregnancy, a bitter fight erupted between them. Local lore claims that the fight may have involved a knife. Afterward, the father of her child vanished and was never heard from again. Sarah's daughter, Rufina, was born out of wedlock. Supporting Marie's thoughts that the "presence" in her café was Sarah, she continued to have more interesting incidences.

Eventually, Marie brought in a friend of hers, Charlie, to finish the job restoring the damaged household. Although there was no voice telling her

to get rid of the man, it still did not go smoothly. After a few hours of work, Charlie came out from the back, walked straight up to Marie and told her that she must do something about "that" woman. "I can't get any work done. Tell her to stop kicking the buckets around."

As Marie recalled the event, she remembered being very flustered. "I had never told anyone about hearing a woman's voice. I thought people would think that I was crazy." Unsure of exactly what to say at that moment, Marie headed to the back where the buckets of stucco were consistently being kicked over by no visible force. "I looked into thin air and simply asked her to stop. I told her that we were trying to fix up her house and that he wasn't going to be able to get anything done with her bothering him." Charlie was able to work without any further incidences.

The relationship between Marie Coleman and Sarah Ruiz began somewhere in that moment. As each day begins, Marie always greets Sarah, and she bids her goodnight as she closes up the café. On occasion when Sarah requires Marie's attention, she throws small pebbles at her until she has it. The pebbles that she uses are very unique and are not from the surrounding area. The pebbles that are thrown at Marie are kept in a little jar on a shelf underneath the register. If by chance Marie forgets to tell Sarah goodnight as she is leaving the café, the lights that she had just turned off come back on by themselves, forcing Marie to go back and turn them off again.

Others in the restaurant have witnessed Sarah's activities to gain attention. A waiter who works at the Church Street Café has reported seeing the spirit of an older woman in a long black dress, with her black hair pulled back into a bun. When she is seen, she appears to be doing household chores such as sweeping or dusting.

Another incident occurred during a Spanish guitar player's session on a Sunday afternoon. It happened in front of all of the patrons and employees. A coffee cup that was placed at a waitress station levitated off a table and slammed into the nearby wall, crashing to the floor in little pieces. To this day, that same guitar player will not play that particular Spanish tune. He believes that the breaking of the cup was Sarah's way to show her dislike of the song. Several years later, the same musician had another strange encounter at the café. He had been talking to his girlfriend about the hauntings at the café and the variety of odd experiences that have occurred to the staff and customers over the years. His girlfriend was skeptical but agreed to go with him to the café to have dinner and check out things for herself.

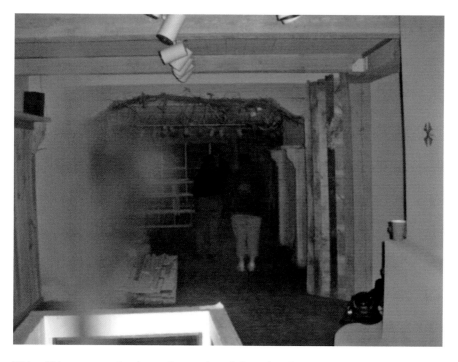

This odd image was taken in another section of the café before it was renovated. Today, it is a beautiful dining room. *Photo by author.*

The evening was uneventful until they finished their meal and were about the leave the café. Suddenly, the light in the lobby went out. All of the other electrical devices were on, as well as the lights in the merchandise cases. The second she walked out of the door, the light turned back on by itself.

The musician's girlfriend isn't the only skeptic on whom the ghost has chosen to play tricks. Marie Coleman's brother came around the café to help out when it was first opened. Disbelieving in ghosts and all other paranormal activity, Sarah chose to play pranks on him to possibly change his viewpoint.

On the first night that he locked the café up alone, he checked that everything had been turned off and began heading for the door to leave. Unfortunately, he was unable to find his keys—obviously a problem because he was locked inside. He double-checked all the places he thought he might have left them and then began to search all over the café. Hearing a female's laughter as he was down on his knees searching the bathroom floor, he called out, "All right, Sarah, leave me alone!" Standing up, he heard the jingling of keys in his pocket. He reached down and there they were. Trying to dismiss the event, he walked to the entrance to find the door wide open when before

it had been locked. Marie says that from that day on, he never spouted off his skepticism about spirits.

One of Sarah's favorite activities is to move objects in a large display case in the lobby of the café. The case is full of figurines and pottery that appear in different positions each morning that the store opens. Some items were beginning to be pushed so close to the edge of the shelves that they were in danger of falling off and possibly being broken. At first, Marie tried to reason with Sarah, but her attempts failed. Sarah began to throw one of the figurines against the glass with such force that Marie was worried that both the figurine and glass would break. To avoid the situation happening again, Marie placed a large piece of pottery on the edge to prevent the figurines from falling over the edge. The movement of the figurines is one of the more interesting occurrences. At times, it appears that Sarah is re-creating scenes with the figures, as if trying to tell a story of events that happened long ago.

Although Sarah Ruiz often appears to hang around only to tease and torment the patrons who pass through her home, her presence is accepted and cherished by Marie and those who care to listen to her stories. The Church Street Café and its resident ghost continue to welcome all into their home.

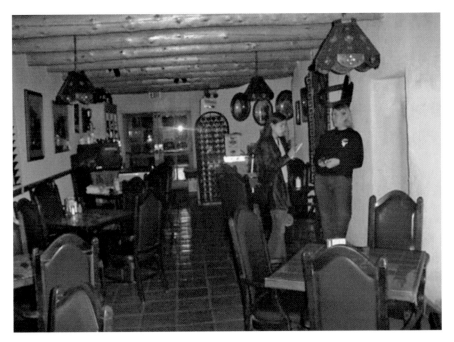

A photograph taken in one of the restaurant's dining areas during an investigation with the *Daily Lobo. Photo by author.*

Rating: Probable

During an investigation at the café, two of SGHA's team members and two reporters from the *Lobo Daily*, both skeptics, heard knocking coming from the adjoining room while conducting an interview in the lobby. It was described as loud knocks, a series of four, that seemed to be coming from the southwest dining room. An infrared camera was set up in the adjoining room, but it did not capture the sound of the knocks.

However, the camera clearly captured the conversation going on in the lobby. It was also positioned such that if anyone entered the room, they would have had to pass by the people in the lobby and sneak around the camera to prevent being caught on film.

No one was recorded entering the room, and the investigators checked the room after they heard the knocking. The area outside the café was also promptly checked. The "knocking" could not be accounted for.

During the spring of 2004, the Travel Channel was filming at the café for its series *Weird Travels*. Bob Carter and I were interviewed for the show at a local hotel. Afterward, we decided to eat at the Church Street Café because we knew that reenactments of the ghost stories were being filmed there, and we wanted to check it out. We were seated in the lavish back patio and promptly ordered our food. On the other end of the patio, several actors were rehearsing the "fight" scene between Sarah and her lover. They had a knife prop and practiced the scene briefly before filming it.

At this time, Bob started to become disgruntled. His Dr. Pepper was empty, and the waiter had yet to return to our table. So, grabbing the empty glass, Bob decided to go look for him inside the café. He was gone for less than a minute when he suddenly came running out of the building and back to our table. "Do we have any equipment with us?" he yelled at me, referring to the equipment that we use in ghost hunting.

"I think we have a kit in the car," I replied.

"Then go get it! Stuff is going on inside!" He turned and ran back into the café, with me on his heels. When I entered the café, I immediately noticed that several of the afternoon customers were standing with their backs against the wall. Silverware covered the floor, as if someone had swatted them off the tables in that rear dining room.

After talking to the customers, a few of the staff and a very irate Travel Channel cameraman who had just missed a good shot, I discovered what had just happened. According to the witnesses, silverware started flying off the tables as if an invisible person was running from table to table and throwing the forks and knives to the floor. I retrieved the kit, and Bob and I searched

the dining room, but we did not find anything unusual. We wondered why the activity would suddenly pick up like this, but then we recalled what scene was being filmed back in the patio.

"She doesn't like it when that little incident is talked about," Marie informed us when we talked to her about the "fight scene" that was filmed outside. Perhaps Sarah was showing her discontent by throwing the silverware around. Oddly enough, the fight scene did not make it into the final cut of the show. Regardless, the event was witnessed by a dozen people in the main dining room.

Most of activity tends to occur in the late afternoon, although Sarah Ruiz has occasionally been seen in the early morning hours. The display case containing the figurines that Sarah moves is located directly on the west wall when you first enter the café.

CURIOSITIES

The window located inside the women's restroom was once the original rear window of the house. Everything from there on back is an addition to the original house. Another interesting tidbit can be found if you go around the east side of the building. You will notice a door about twenty feet or so down the alleyway. Now go inside, enter the second dining room, straight back from the café's entrance, and try to locate to the same door. It isn't there.

CHAPTER 9

SARGE, THE CONFEDERATE GHOST

For thirty-six days in 1862, Albuquerque became the Confederate capital of New Mexico. After a bloody battle, a portion of the Fourth Regiment of Texas Mounted Volunteers under the command of General H.H. Sibley failed to take Fort Craig, south of Socorro. In need of supplies, the exhausted troops pushed on to Albuquerque. Union soldiers, meanwhile, had moved everything possible from their Albuquerque post, burned everything remaining and retreated north under Captain Herbert M. Enos.

The Confederates entered Albuquerque on March 7, held a ceremony to claim the village and New Mexico for the Confederacy, fired a thirteen-cannon salute and raised their flag on Old Town Plaza. Albuquerque was under its fourth flag in 156 years.

For two weeks, the Rebels foraged for food in the Sandia Mountains and relaxed in the plaza. Rumor has it that Sibley commandeered the house belonging to merchant Franz Huning, now the Manzano Day School, southeast of the plaza. Then they marched north to engage the Union forces at Fort Union but ultimately met with disaster at Glorieta Pass. After their supply trains were burned in Apache Canyon, the Confederates fled back to Albuquerque.

On April 10, there was a minor skirmish when Confederate forces dug in near Franz Huning's mill, ironically named "La Glorieta," east of Old Town and exchanged artillery fire with Union forces at nearby Barelas. After Union forces withdrew, Sibley decided to marshal his men and leave for El Paso. Their last actions were to see that the injured men left behind were

Left: A plaque at Old Town Plaza about the "Skirmish of Albuquerque." Many historians disagree with the version recorded on the plaque. *Photo by author.*

Below: The replica cannons at Old Town Plaza. The original remaining cannon is on display in the Albuquerque Museum. *Photo by author.*

provided for in the local makeshift hospital and to bury eight twelve-pound howitzers captured from Union forces in a corral northeast of the plaza. On April 12, the last of the Confederates left Albuquerque, and the town was once again in Union hands.

However, one Confederate soldier seems to have remained behind, in spirit anyway. Visitors and residents of Old Town Albuquerque have reported seeing an unusual specter of a Confederate soldier, sometimes on horseback and sometimes walking on foot, on San Miguel street north of the

plaza. One of the oldest stories came from a city worker who was driving a street cleaner through Old Town one evening:

It was around midnight when I turned north onto San Miguel street. I was in a hurry to finish the job and get home when I noticed a figure on horseback in the street ahead of me. I was heading straight for him, yet he didn't make eye contact. The soldier and horse didn't flinch or glance in the direction of the vehicle. It was as if the vehicle didn't exist.

Surely, humans would, out of curiosity and caution, look to see if the vehicle was going to stop. The Confederate soldier just stayed put, sitting calmly on his horse looking downwards. I assumed that this guy must have been dead drunk because of his lack of caution. He was dressed in gray, his face was almost concealed in his long salt and pepper beard as his head was bent forward.

I hit the brakes and brought the street cleaner to a stop just before I reached him. The horse and rider were directly broad side to me and because of their position in the middle of the road; there was not enough room to go around them on either side.

This really annoyed me. I started honking the vehicle's horn at him, but the rider refused to move. He seemed totally oblivious to my presence.

Finally, I backed up, disengaged the street cleaner and drove up onto the west curb. I slowly went around him, glaring at this crazy moron until I was past him and could drive off the curb again. I then tried to re-engage the street cleaner. The gears made a grinding sound and would not engage, despite how much effort I put into it. I went from being just annoyed to being really angry. After all, if it wouldn't have been for this drunken civil war re-enactor guy blocking my path and being a traffic nuisance, I would have already been off this street and almost finished.

In a burst of anger, I opened the door and stomped around to have a few "words" with guy but when I came around the rear of the vehicle my anger turned into shock. There was no one there. No re-enactor, no horse, nobody. I quickly looked around the area and listened for any sounds of the horse moving through the silent empty streets. There was nothing. That was when I put two and two together.

Now I can understand if the rider was so drunk that he didn't notice me but what about the horse. When I was honking my horn, the horse didn't react either. Surely the loud horn would have startled the horse or at least caused some reaction but it didn't. The horse just stood there, oblivious to the world just like its rider.

The unusual thing about the Confederate ghost, like many of the ghosts in Albuquerque, is that he is seen as a solid object rather than a glowing translucent mass. The street cleaner was convinced that the ghost was an actual person until he and his horse suddenly vanished. The same fact holds true in another sighting, although this one is interesting because the witness *was* a Civil War reenactor:

> *My wife and I had just finished eating at a fondue restaurant north of Old Town and we were walking south down San Miguel street to the parking lot where we had left our car earlier in the day. We were walking down San Felipe Street when I noticed a Confederate reenactor walking the other way across the street. What particularly caught my attention was the Whitworth rifle he was carrying. Being a Civil War reenactor myself, I was curious about where he had gotten it.*
>
> *I made a remark to my wife about this who simply suggested that I ask him about it.*
>
> *So I crossed the street and began running after him. Just before I caught up to him, he turned to the right into a section of shops.*
>
> *When I came around the corner, he was gone. I was only about 6 or 7 seconds behind him, yet there was no sign of where he had gone. All of the shops were closed and I would have heard a door opening or seen something to indicate where he had gone.*
>
> *Had I just seen a ghost?*

Finally, a tourist visiting Old Town e-mailed SGHA claiming that he had heard the sounds of a horse following him while walking back to his car. He stated that he could hear the horse but could not actually see it. He also noted that the sound seemed to change in direction, as if the horse was coming at him from different directions.

Rating: Debunked
This ghost has been completely debunked. All of the witness sightings have been replicated, and the history itself does not support the story.

HISTORICAL INACCURACIES

The plaque on the gazebo in Old Town indicating that eight Confederate soldiers were buried there is incorrect. The New Mexico Archaeology

Department confirms that there were no Confederate troops buried in Albuquerque during the war.

During the Civil War, the Texas Mounted Volunteers attempted to conquer New Mexico for the Confederacy. The historical record shows that the Texans fought with a fair amount of firepower, with several batteries of artillery. On February 21, 1862, these artillery units inflicted great damage to the Union soldiers at Valverde, and McRae's Union Battery was also captured. This gave the Texans an additional five guns: three six-pounders and two twelve-pound howitzers.

General Sibley made the decision to abandon about half of his artillery in Albuquerque to lighten the load and to use the carriages for hauling the few supplies they had left. Late Friday night, April 11, the Texans dug a hole in a corral northeast of the Albuquerque Plaza and secretly buried eight cannons of Reily's and Wood's artilleries. This was done to ensure that the discarded cannons would not fall into Union hands.

The following morning, they began their trek to San Antonio, Texas, with the four six-pound guns of Teel's Light Artillery and the five cannons of the captured McRae's Battery, now Captain Sayers's Valverde Battery. The Texans ran into the Union forces at Peralta. Teel's six-pounders and a few of the Valverde cannons were used against Canby's men in the daylong skirmish.

After leaving La Jencia, the Texans marched across the plains and camped at Ojo del Pueblo, near present-day Magdalena. Hauling the artillery along the route of the sandy and mountainous retreat was becoming cumbersome, as expressed by Peticolas: "Sunday, 20 April 1862. Some talk of spiking the artillery and leaving it; 2nd Regt. And Green has gotten tired in one day of helping their battery along, but it was not done. Scurry undertakes to take them through and will not consent to leave behind us the only trophies we have been able to keep of our victories."

From this diary entry, it was clear that the McRae cannons, the "trophies," were with Scurry's command (Peticolas's regiment) and Teel's Battery assigned to Lieutenant Colonel Green. This also seemingly proves that none of McRae's five cannons was buried in Albuquerque, as some historians believe.

From Ojo del Pueblo, the Texans marched along the western edge of the Magdalena Mountains to Texas Springs and then south along the San Mateos, roughly following what is now NM 107. On April 21, Peticolas wrote, "[P]assed in sight of Ft. Craig…Climbed a high steep hill, dragging up the 8 heavy guns." Historians have struggled with this entry for years.

An actor dressed up to resemble "Sarge." *Photo by author.*

If the Texans had nine cannons on April 19, what had happened to one of them by April 21? The answer is not relevant for this report, but the historical record clearly shows that there are not any other cannons buried in Albuquerque. Finally, it should be noted that there were no casualties during the Battle of Albuquerque.

These historical facts debunk the "purpose" of the haunting in Old Town. There is simply no reason for a ghost to be haunting that area.

SKEPTICAL REVIEW OF THE FIRST SIGHTING

Police records from this time show an arrest of an intoxicated man riding a horse on Central and Rio Grande Boulevard at 2:30 a.m. This was fifteen minutes after the sighting by the city employee. We also timed exactly how long it would have taken for a city employee to move the street cleaner as it was described. The maneuver took twenty-five seconds, which is more than enough time for the horse and its rider to wander away onto Church Street.

SKEPTICAL REVIEW OF THE SECOND SIGHTING

This actually was another Confederate reenactor. The Sons of Confederate Veterans and other groups were demonstrating Confederate and Union camp life that day. Artillery and marching demonstrations, as well as reenactments of the historic battles in New Mexico, were held at the museum on this date.

Six seconds is more than enough time for the Confederate reenactor to have reached the back gate at a "brisk stride." We eventually found the reenactor himself and asked him about that night. He told us that he had been at a restaurant when some of the people there started making disparaging comments about his uniform.

"They were calling me a racist and all sorts of other things," he told us. "For a while, I was worried that a fight might break out." After he had finished his meal, he was on his way back to the camp when he noticed someone running after him. Thinking that it was one of the people from the restaurant looking for a fight, he ran as soon as he got around the corner. The museum gate in this area was open, allowing him to reach the camp safely.

SKEPTICAL REVIEW OF THE THIRD SIGHTING

The sound of the horse was replicated in 2005. After a rainstorm, water dripping into a gutter on Church Street can mimic the sound of a horse's hooves. The sound's directional change is caused by the echo and the listener's position in Old Town. We were able to hear the rain dripping down the gutter as far away as the plaza when traffic noise from Rio Grande Boulevard was minimal. Interviews with Old Town residents reveal that there have been no sightings of this ghost by the locals. It would seem that if there was a ghost riding around, one of them surely would have noticed.

LA CAPILLA DE NUESTRA SENORA DE GUADALUPE CHAPEL

Tucked away behind quaint small shops in Old Town lies a small chapel that, according to legend, is haunted by an apparition called the Lady in Black. This mysterious figure has often been seen seated on the far right bench of the chapel, weeping profusely for some unknown tragic loss. The ghost is dressed in a long black dress, with her face concealed by a dark veil. She is often mistaken for a real person and sometimes ignored, until she mysteriously vanishes.

Here is the story that describes an encounter with the Lady in Black that got us interested in investigating the location:

> *I once visited the small chapel in old town late one evening to say a prayer for my brother, who was ill. As I walked into the candle-lit entrance, I heard a woman softly crying. Her voice was coming from somewhere near the altar, which at that time was shrouded in darkness. I strained my eyes and could barely make out the figure of a woman wearing a mourning dress. I then turned my attention to my own business. I kneeled at the shrine for our Lady of Guadalupe and said my prayer. However when I opened my eyes and stood up, I noticed that the woman was gone. The only way out was directly behind me and I am certain that I heard no one pass.*

The apparition is not menacing or threatening. Those who encounter her have said that there is a deep sense of sadness that emanates from her. In

The Old Town Chapel, near the Albuquerque Museum. *Photo by author.*

some respects, the ghost resembles La Llorona of Hispanic folklore but only in the sense that both ghosts are known to weep.

Over the years, there have been several speculations on who or what the ghost is. One popular notion is that the ghost is crying for the victims of TWA Flight 260, which crashed into the Sandia Mountains on February 19, 1955. All thirteen passengers and three crewmembers onboard were killed in the crash. According to this variant, the ghost appears on the anniversary of the crash. Another theory is that the ghost only appears in times of tragedy. If there is a fatal crash on the interstate or some other catastrophe, her apparition appears and mourns the loss.

The history of the chapel itself may offer some insight on which variant of the story may be correct, if either is correct at all. Sister Giotto was the person responsible for designing and building La Capilla de Nuestra Senora de Guadalupe, which was erected in 1975. It was part of a larger project, an art school that she had established in 1969. The Sagrada Arts School eventually consisted of studios, apartments, the chapel and even a restaurant called Joseph's Table.

Sister Giotto was born in 1927 and raised in Chicago, where she attended high school at Chicago's famous Art Institute. When she was seventeen,

after listening to the boys coming home from World War II and praying for them daily, she had a conversion experience. She then entered a Dominican convent and studied in Florence, Italy, eventually receiving her MFA from Wisconsin. After returning to her alma mater in Florence, she held the position of dean of the art department at Villa Schifanoia for eight years.

In 1965, the Vatican urged that schools of sacred arts should be set up wherever possible, and soon afterward, Sister Giotto got permission to set up such a school. She chose to come to New Mexico because "it had its own indigenous religious art…no other place has this." She found a piece of land north of Old Town Plaza that was owned by one of the investors in the Sheraton Old Town, Mr. Wolfson. She fixed up the property after getting a thirty-year lease from Mr. Wolfson. He charged her rent of just one dollar per year. Eventually, she bought the property.

Part of the school incorporated the remains of an old fort: five rooms at the front of the two-story apartments had formed a Civil War–era barracks. They became studios. Sister Giotto's brother-in-law, George Sandoval, had a furniture building and woodworking shop where the High Noon now stands. She slept in his shop for a while and then moved to the convent next to San Felipe Church.

Finally, construction on the chapel was started. Volunteers did all of the work, many of them from Mexico. As construction on the chapel slowly continued, two unique incidents occurred in her favor. First, Mr. and Mrs. Kaiser from Tucson presented her a portfolio of Ansel Adams's work. She sold it to the Smithsonian for $20,000. This gave her the money to finish the chapel. Then one day, a man involved in the construction trade named Mike was sitting in the bus station in Milwaukee, wondering what to do for the next year or two. He overheard two people talking about Sister Giotto's chapel, came to Albuquerque and ended up finishing the chapel, as well as the gift shop in front of it.

Just inside the chapel, on the left, is a beautiful calendar window. According to Sister Giotto, she wanted to show that contemporary art belongs in a traditional setting. It shows the Feasts of the Virgin and the phases of the moon. The window consists of three Plexiglas panels. The middle panel can be adjusted for any year, so that in effect it is a perpetual calendar.

The benches and inscribed tablets that adorn the main room of the chapel were done it Italy when Sister Giotto was living there by Meinrad Craighead. The sister carved one of them herself, but the rest were done by Craighead. They were originally carved for a chapel in Italy, but for some reason they could not be used there, so they were packed around a lithography press in a

The calendar window of the chapel. *Photo by author.*

crate and shipped to Albuquerque. Sister Giotto would ring the chapel bells every morning at six o'clock for prayers. Afterward, everyone would share fresh bread that the sister had baked in the restaurant.

Although Sister Giotto had received a special dispensation to build the chapel, it was never actually consecrated by the Catholic Church. This explains why the capilla is maintained solely by volunteers. But is it haunted?

As one can see, the airplane crash theory makes no sense. The crash happened in 1955, while the chapel itself was not built until 1975. The "ghost" has also eluded many ghost hunters who have swarmed over the chapel on February 19 for the past several years. As for the other theory, who knows?

Rating: Debunked
It is my personal belief that the chapel is not haunted. It never was. The accessibility of this site makes it the most frequently investigated location in the state. The few other reported "sightings" are typical of psychosomatic response episodes that are common in poorly lit areas. Additionally, all of

the evidence that the Lady in Black is a ghost is loosely based on the fact that she mysteriously vanishes.

The chapel has a south doorway that is often left open in the warmer months. A person seated on the west bench could easily exit the building without attracting the attention of someone kneeling at the shrine near the entrance. It should also be noted that while at the shrine, one does not have a clear view of the chapel's main room.

After the sightings at the chapel were thoroughly explained, the location was added onto the ghost tour of Old town—not because it was a "haunted" location but because we needed to add fifteen minutes to the length of the tour. Since the Lady in Black closely resembled the legend of La Llorona, we used the stop as an excuse to tell the Llorona legend. After explaining that the chapel was not haunted, we let them go inside to view this beautiful piece of Albuquerque's history.

Despite this, I have run across many people who believe that a ghost appears there and even a few who insist that it is not a ghost but rather Albuquerque's patron saint, Our Lady of Guadalupe. There are also other ghost tours that still claim the chapel is haunted, basing their information on extremely poor sources.

Although I have never had an experience of a paranormal nature in the chapel, there is one rather humorous situation that bears mentioning. Inside the chapel on the left as you turn into the main room, there is a small doorway that is the entrance to a confessional. A small hole was constructed through the south wall of this room, allowing someone to enter the main room and give confession to the priest inside.

Several years ago, one of the guides of the Old Town ghost walk would lead his tours into the main room to talk about the chapel. During his performance, he would stick his hand into the hole and pretend that he was grabbed by someone inside, startling the tourists on the tour. I had always felt that this was disrespectful to the chapel itself and asked him to stop that. However, by this time it had become a part of his routine, and sometimes routines die hard.

This, combined with the fact that it is *not* haunted, led to my decision to take action. So, one evening I decided to "emphasize" my point. After confirming that I had the right tour guide leading the tour, I went to the chapel and hid inside the confessional. There I waited in the dark for that special moment when the tour guide would insert his hand into the hole.

Finally, the tour arrived at the chapel, and when he inserted his hand, I grabbed it and pulled. He screamed in a high-pitched voice and tried to

pull his hand out, but I held fast for a few more seconds before releasing it. Although it probably scared the tourists as well as the guide, my point had been made. It's not a good idea to put your hand into dark holes in the wall, especially when you do not know what is on the other side.

To the best of my knowledge, that guide never again attempted to startle his guests in the chapel.

CHAPTER 11

THE HIGH NOON RESTAURANT

425 San Felipe Street

Constructed in about 1785, the building in which the foyer and Santo Room of the High Noon Saloon are located is one of the original structures in historic Old Town Albuquerque. August 20, 1850, is listed on the building's original territorial deed as the date of the first recorded sale of the building, when Quereva Griego de Chavez purchased it from Jose Delores Chavez.

It changed owners four additional times between 1884 and 1965, when the present owner, George Sandoval, purchased the building from Carlos Vigil. He used it as a furniture building and woodworking shop for many years. Mr. Sandoval was the brother-in-law of Sister Giotto, who built the La Capilla de Nuestra Senora de Guadalupe, a small chapel that is located nearby. It is also interesting to note that Leonardo Huning, whose family built the famous Huning Castle that stood nearby on Central Avenue for many years, owned the structure from 1887 to 1894.

When the building was first constructed, it was a typical Spanish home. Not long afterward, the building was sold and became a brothel and gambling casino. Whiskey, prostitution and gambling blended together as men came into town on payday to spend their hard-earned money, and the women were more than eager to accept it. Some of these "colorful" ladies wore elaborate gowns with jewels; others dressed in black silk stockings with scanty costumes. Although age was not really a factor, the majority of the

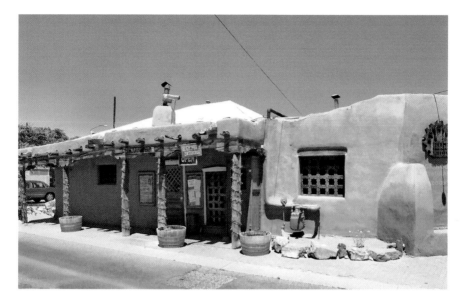

The High Noon restaurant on the corner of Charlevoix and San Felipe Streets. *Photo by author.*

girls employed by the brothel ranged from sixteen to thirty-five years in age. Due to its size, it was too small to have been a parlor house; it was probably not elegantly furnished, but it still offered warm hospitality.

It had a comfortable saloon where the men could enjoy a drink and a bit of conversation with the prostitute before he requested her sexual favors. When he was ready, he simply asked her if "she wanted to go for a walk." She would always say yes, though it is doubtful that she ever felt any romance, as sex was her business. The ladies also sold beer and whiskey to the customers at inflated prices, as well as encouraged and cheered the gamblers on. The proprietors of these establishments also had to be constantly on guard for signs of drunkenness and suicide. When the girls became depressed, they would drink, and customers did not want an unattractive drunken woman. Suicides were quite common as well. The girls would typically take an overdose of a type of opium called laudanum. Perhaps this is why so many brothels are haunted today.

A great deal of the detailed history of the building has been lost, but it is known that at the turn of the nineteenth century, it had been abandoned for almost ten years. This was when several of the nuns from the church settled into the structure and adapted it into a small sanctuary.

The building, as it exists today, was completed by Mr. Sandoval when he added the areas now called the Gallery and the Kiva Rooms. In October 1973, High Noon Limited began its renovations of the building for a bar and restaurant. Today, the building is home to the restaurant, and it seems that a few of the former residents have refused to leave. The building is believed to be haunted by two different spirits, one male and one female.

Suzie Baca, one of the restaurant's servers, believes that a trapper may haunt the restaurant. The ghost is often absent for long stretches, as a trapper would have been during Albuquerque's pioneer days. When the male ghost is present, he makes himself known by rattling dishes and calling out the employees' names. The female ghost is also quite vocal. Her voice has often been heard in the Santo Room late in the evenings after the restaurant is closed. Her identity is still a mystery. Some believe that she is the spirit of one of the prostitutes or perhaps even the madam of the brothel and gambling hall. Others speculate that she is connected with the building from when it was a home.

The fireplace that sits between the newer and older sections of the building is often an active area for paranormal activity. The distinctive

The Santo Room. *Photo by author.*

smell of smoke can be perceived even when there is no fire burning in the fireplace. Often this causes quite a stir among the staff, who frantically try to determine the source of the smoke before calling the fire department. During one Christmas Eve, the smell of the smoke even resembled piñon.

Customers and employees have also felt taps on their shoulders by an unseen presence and heard the sound of footsteps. The footsteps, most commonly heard in the Santo Room, sound as if someone who is wearing boots with spurs is walking across a wooden floor. The footsteps cease when they approach the newer section of the building. One tourist, Allen, recalls the distinctive sound of the ghostly boots walking by his table while dining at the restaurant: "My wife and I were having a cup of coffee after dinner when the sound of heavy footsteps filled the room. I turned to see who this person was, but no one was there. The footsteps literally went right past our table and across the room toward the bar. We both recall a slight ringing noise just before the sound of each step. It was really weird."

Noises are not the only phenomenon that has amazed patrons; faint apparitions have been reported as well. One evening, after the restaurant had closed, a bartender was cleaning up the bar area when, out of the corner of her eye, she saw an "unusual human-shaped form" in the foyer. She described the figure as "too tall to be a woman, wearing a robe or cloak." Assuming that the figure was a customer who had accidentally become locked inside, she grabbed the keys and went to unlock the door for him. When she arrived in the foyer, it was completely empty, and the front door was still locked. There was no way anyone could have exited the foyer without her seeing him.

Other ghostly activity in the foyer has been reported by hostesses late in the evenings. First, there is this unusual feeling that they are being watched. Then they notice movement out of the corner of their eyes and see a man looking in the window at them. When they turn toward the window to see who is there, the figure simply vanishes. The bar appears to be another very active area. One evening, a customer's beer went flying off the table here. Witnessed by several people, the beer seemed to just "jump" off the table.

Suzie's first experience with the male ghost occurred one night after closing. She let the staff leave early and was in the restaurant alone. She finished up a few chores and then she went back in the kitchen to turn off the lights. She approached the breaker box and began turning off the lights and fryers when she suddenly heard an odd noise behind her. Turning around, she discovered that the plates that were lined up on the preparation table had moved. As she moved closer to examine them, the plates moved

again, as if an unseen hand was moving across them, causing them to shift. The movement increased until the whole table was shaking violently. She immediately left the building. She no longer closes the restaurant by herself.

Shirley, another employee of the restaurant, described the female ghost as wearing a formal dress. On one Christmas Eve, the ghost was seen wearing a gray mourning dress with a bustle. Few people who have seen her realize that she is a ghost. She can be identified by her stillness and period dress. Shirley's most unusual encounter occurred one day during the noon rush hour when she was heading to the kitchen from the Santo Room. When she opened the door and entered the hallway, she ran into an "invisible" man and seemed to knock him down.

Psychics who have visited the building believe that the name of the male ghost is Frank. He haunts the building because he was murdered and robbed by one of the ladies of the night who was employed at the building when it was a brothel. Based on the information from the psychics, the staff began referring to the male ghost by that name. Soon afterward, a regular customer had an uneasy experience in the lobby. He claimed that he felt a "spirit" was blocking his way into the Santo Room. When he tried to move around it,

Unusual electromagnetic readings behind the bar at the High Noon. *Photo by author.*

a disembodied voice shouted out, "My name is not Frank!" The ghost has not been called by that name since. The male ghost is also believed to flush toilets and pinch ladies in the women's restroom.

If the ghosts that lurk inside are not enough, the parking lot appears to be haunted as well. The ghost of a nun in full habit has been spotted on several occasions wandering around the parking area of the restaurant. She appears to be searching for something, and if approached, she vanishes into thin air.

Rating: Improbable

To understand why I rated this one as improbable, it is necessary to understand a little local history. When my business partner Buck and I were developing the ghost tour in Old Town, we went to every single building, told the owners what we were putting together and asked if they had unusual occurrences happening that we could add to the tour. Initially, the High Noon owners said that they had nothing paranormal at all occurring inside their building.

Several months later, we launched the tours. The tour route at that time went directly by the High Noon, en route to the Maria Teresa Restaurant on the other side of Mountain Road. After a year of the tour going by with more than twenty tourists in tow, we were finally told that High Noon did indeed have a ghost, but just one. It just seemed suspicious.

Regardless, SGHA began a series of investigations. In the six times we have investigated the building, we have never found anything tangible that would indicate that anything paranormal is occurring. If we are to believe the psychics, then the ghost comes and goes, so maybe we were there when the ghost was out. I do believe the testimony of the witnesses; however, like so many places that are rumored to be haunted, myth building is very active here. As I stated earlier, we were initially told that there was only one "ghost." Now the building claims to have four. This puts the "evidence" firmly in the witness testimony, which is only anecdotal at best.

CURIOSITIES

The Santo Room is Spanish and features original antique santos (statues of saints) from Mexico and the Philippines. They have been in the Santo Room since 1810. The rooms that people describe as feeling the strangest are the restrooms—the rooms where prostitutes entertained their clients so long ago.

ALFREDO'S COFFEE SHOP

Nestled in the north of Old Town, Alfredo's Coffee Shop offers a variety of live music to accompany its unique menu and caffeinated delicacies. The front room of this building was constructed before 1706 as a Native American residence. Made of adobe bricks that are mortared with mud and then protected with a layer of mud or cement, much of the original walls remain. The original vigas (wooden beams) are still visible in the ceiling. Efficiently styled fireplaces called kivas were the primary sources of heat.

In 1680, the northern Pueblo Indians revolted against the oppression of Spanish rule, forcing the Spaniards, many of the colonists and even the southern Pueblo Indians to flee New Mexico. Most fled to the south along El Camino Real and relocated along the lower Rio Grande around present-day El Paso, Texas.

The Spanish eventually returned and constructed a small presidio (fort) just north of a small settlement that would eventually become the city of Albuquerque. The back of the building was where the horse corral was located. This has since been built over and is now the main room of the building where bands play to the establishment's clientele.

Properties on both sides of Carnuel Street were first owned by the Diego Sanchez family in 1690. The street was eventually renamed Charlevoix Street after another owner of the land, Charles, a Frenchman who operated a stable and Old Town's weigh station. Charlevoix is French for "Charles' view." Charlevoix Street was also nicknamed Burro Alley due to the laws that prohibited the animals in the plaza. In modern times, the building has

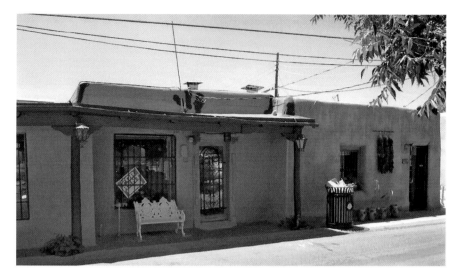

The location of Alfredo's Coffee Shop, now for rent. *Photo by author.*

served as a restaurant, various mercantile shops, a bicycle shop and now a coffee shop.

It is also interesting to note that the coffee house is only one small part of the ancient Spanish fort. The fort extended east to San Felipe Street and then turned south. Other shops within this area have also reported unusual occurrences that are similar in nature to those that occur at this location. However, the locations on San Felipe Street seem to be more consistently active than the coffee house itself. This may be due to the location of living quarters and defensive positions from when the area was a Spanish fort. It should also be noted that a great deal of the original Spanish fort was destroyed in the flood of 1866.

There are various rumors about the ghost that haunts this café. Some believe that it is a long-passed Native American who still moves about the grounds, but the most popular theory is that it is a Spanish soldier who once occupied the fort. The witnesses of the phenomenon range from the establishment's employees to customers and even the musicians who have played there late into the evening.

Disembodied voices have been heard coming from the kitchen and storage areas. The voices sound like they are speaking Spanish but are mumbled enough so that it is difficult to clearly understand what is being said. Many believe that the ghost is speaking an archaic form of Spanish and that this is

why it is so difficult to understand. Employees at the coffee house have often searched for the source of the voices, believing that a customer had somehow managed to find his way behind the counter. A thorough search of the area always generates the same results: completely empty kitchen and storage rooms. No one is there. On occasion, the sounds of the voices are preceded by the uneasy feeling that you are being watched. Sudden "breezes" of cold air have also been experienced near the counter.

Other unusual occurrences seem to be electrical in nature. The door to the power box located near the front door flies open with force on occasion. No logical explanation can be found as to why the electrical box door would violently fly open on its own accord. Often when this occurs, the heating is turned on. Lights turn on and off, apparently by themselves, throughout the entire location.

One of the coffee house's regulars believes that she can feel a heavy presence, like static electricity, when the spirit enters the room. She describes herself as "sensitive" and believes that the ghost of a Spanish soldier is still following his orders even in death. He continues patrolling the grounds, guarding the building from danger and anything he might perceive as a threat.

Rating: Improbable
The ghost hunt I organized here was very interesting. The west side of the building was swept for unusual electromagnetic fields with a Trifield meter. One photographer followed the instrumentation, while

I took random pictures of the location. After finding nothing of interest, the sweep continued down and up the east side of the location. While taking photographs in the storage room, I suddenly had an unusual problem with my camera. The CD drive seemed to malfunction, spinning the CD (which is not typical, and it hasn't happened before or since) while attempting to photograph the kitchen.

An unusual image taken in the kitchen. *Photo by author.*

84

After several seconds, the drive turned off, and a photograph was finally taken. This is one of the most interesting pictures I have taken to date.

However, this is the only interesting thing that we found at this location despite a multitude of investigations. A skeptical analysis completed by SGHA's skeptics (called SHIELD) was able to replicate the breezes of air, and the phenomenon is explainable as a result of the airflow through the location when the air conditioning is turned on and the exhaust fan is running. The disembodied voices were eventually isolated and determined to be coming from the adjoining buildings and sounds coming from the street. It is also interesting to note that in an interview with a former tenant, no paranormal activity was suggested at all.

Update: Alfredo's Coffee Shop has changed locations, and at the time of this writing, the building is vacant.

CHAPTER 13

THE SALVADOR ARMIJO HOUSE

The Maria Teresa Restaurant has a dubious distinction of being one of New Mexico's most haunted buildings. This homestead, built in about 1783, is now the home of a romantic restaurant. The showpiece is a long bar that was moved from Fort Sumner, New Mexico, in 1970. The bar has the distinction of having quenched the thirst of notorious outlaw Billy the Kid and members of his gang. Wandering its rambling rooms are at least four specific ghosts, whose detailed visages have been recorded by both staff and patrons alike. Often, those reporting the events have never heard of the haunting of this centuries-old home.

The hacienda was built by Salvador Armijo. Born into a wealthy family, he was educated in St. Louis, fluent in both Spanish and English and understood a great deal about economics, trading, real estate and the family business, transporting goods across the Southwest. In 1847, Salvador married Paula Montoya and began buying more land around the house, about one hundred acres, which he turned into vineyards and vegetable gardens. His business ventures also grew. In addition to the real estate he was leasing, he also sold produce and wine and manufactured other goods.

Originally, the building was a twelve-room hacienda enclosing a central patio. It faced south, looking toward the San Felipe de Neri Church and several small adobe houses that clustered around the plaza. Between the house and the church were a few homes, but the area was mostly composed of open fields. The house's layout was typical for haciendas built at the time: a rectangle, one hundred feet north to south and seventy

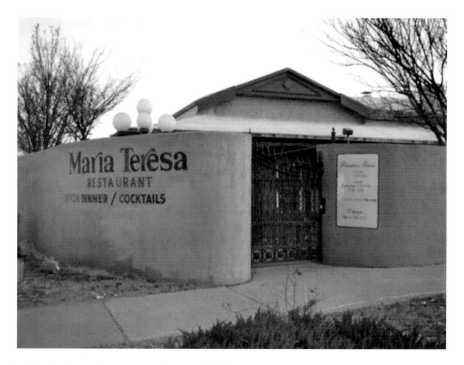

The Maria Teresa Restaurant, formerly the Salvador Armijo House. *Photo by author.*

feet east to west, enclosing a placita. Zaguanes (covered passageways that were usually big enough for a wagon to pass through) were on the east, south and north sides. Each of the hacienda's twelve rooms opened up into the placita instead of the outside. This was an architectural defensive measure that was carried over from Spanish colonial times when each hacienda was a fortress and easily defendable from the local natives. In the center of the placita was the well, with stables and storage rooms to the rear.

The walls of the original house were thirty-two inches thick, with the single exception being the west side, which was built out of stone. The walls of the hacienda were plastered with mud inside and out. The roof was composed of a thick layer of dirt, which was drained by long wooden canales that jutted out on all sides. The family lived in the southern side of the building as storage areas and servants' quarters made up the northern side.

Despite Salvador's success in business, his personal life was in turmoil. He divorced Paula after one year of marriage and started up another relationship with a woman from a prominent local family named Dona

Maria de las Nieves Sarracino. Their relationship quickly turned sour, and the two often feuded over petty things. During their marriage, they only had one child, a daughter named Piedad.

Eventually, Salvador began taking frequent long business trips, leaving Dona Nieves to manage the household and local business affairs. Despite their differences, the two managed to acquire more property, developed one of the largest vineyards in the territory and eventually became the largest agricultural employer in the region.

In 1872, Piedad married Santiago Baca. It was the first wedding held in the San Felipe church after the Confederate invasion of New Mexico. Salvador quickly became close to his new son-in-law, and they went into business together. As a result, Piedad and Santiago became quite wealthy. Salvador and Dona Nieves separated shortly after Piedad's wedding and began dividing up their property, a process that would eventually take ten years to complete. She got the house and part of the farmlands, but more importantly, the settlement agreement determined that Santiago would have power of attorney for Dona Nieves. The couple eventually moved into the house with Dona Nieves.

In 1875, Piedad and Santiago began an extensive remodeling of the home in Territorial style, an adaptation of Greek Revival, which was considered to be more stylish at the time. The southern zaguan was converted into a hall that opened into the rooms on either side. Windows were also added to the exterior, and portales (covered porches) were built along the west, south and east walls, as well as along the interior of the placita.

The years that followed were painful as the couple's wealth began to decline. Dona Nieves, who had never been easy to get along with, became even more difficult in old age. She ruthlessly tried to rule the house. Even more complications arose when Bernardino, Santiago and Piedad's son, moved into the house with his new bride. Playing his grandmother against his parents, the son caused an irreparable rift in the family. When Dona Nieves decided to deed the western section of the house to her grandson, Santiago and Piedad moved out in anger, and Santiago terminated the power of attorney that he had held for the last twenty years.

Things became even worse for Dona Nieves when she discovered that her grandson had sold some of her property without her knowledge. She filed a suit against him and went to live with her granddaughter, Francisca, while the legal proceedings dragged on. She died there in 1898 with her personal affairs in chaos. Francisca's husband, Meliton Chavez, bought the house in 1899. Santiago and Piedad returned to the

house and remained there for the rest of their lives. Piedad passed away in 1907, and her husband followed almost a year later.

Meliton and Francisca moved into the house and began a series of renovations in 1908. The west side of the house was already in bad condition, so it was removed. A new living room and bedroom were built on the south side, making a double row of rooms. The exterior walls were covered with a cast-stone veneer, and portales were built along the south and west exterior walls. The final touch was covering the old dirt roof with a new low-pitched one.

The house eventually passed into the hands of Alejandro and Piedad Sandoval, the daughter of Francisca and Meliton. When Meliton died in 1933, he willed the south part of the house to Piedad and the north section to his granddaughter, Frances Wilson. After her mother's death, Frances became the sole owner of the house. The building received its last major remodeling in 1977, when Frances leased the house to the Tinne Mercantile Company, which converted it into a restaurant.

The restaurant changed hands again in 1984 when the Old Town Development Company acquired the restaurant. Since then, it has changed ownership several more times. Although the house has been remodeled often, the basic house is still intact, and it appears that some of its former residents have refused to leave. Practically every room has its own story and experiences. Each room of the house is named after the families who once lived there. The restaurant is entered through the remains of the old placita on the west side.

Several sightings of apparitions have been reported in the Armijo Room. In one instance, a waiter returned to ask if anyone wanted dessert or coffee. He was informed that a woman in a white dress had already taken their dessert order. This was made interesting by the fact that the female staff of the restaurant wore maroon dresses. When he asked his customers what this woman looked like, they described her as a Hispanic woman who was about fifty years old, with dark hair with streaks of gray running through it. Her hair appeared very neat and was tied up into a bun. The full-length white dress she wore was decorated with small white beads about the collar and bosom.

The woman in the white dress also frequents another dining room named the Wine Press. She has been seen by busboys in the area outside the restrooms and by female customers, who have also reported an odd feeling of being watched while in the women's restroom. The busboys have described a fleeting image of a woman dressed in white, which is followed by a chilling gust of air.

The Armijo Room. The portrait of the waiter hater dominates the room. *Photo by author.*

The restaurant's employees believe that this particular ghost may be Dona Nieves, Armijo's second wife. One Easter Sunday, Daniel Lamb, the restaurant's headwaiter, returned to a table to take a dessert order to, once again, discover that the customer's order had already been taken by a woman in a white dress. However, there was something different this time. The woman was pushing a dessert cart. A very interesting situation indeed, considering that the restaurant does not own one.

Another type of activity that frequently occurs in the Armijo Room involves the unexplainable movement of silverware. A former waitress described the scene: "A couple times I've been alone in the house and have set up all of the place settings. After rechecking all the dining rooms for the night, I discovered that the flatware on the tables in the Armijo room has been moved, usually in one large pile upon the table." Another waitress had a slightly more dramatic experience when she entered the Armijo Room carrying a tray full of water glasses. The instant she crossed through the threshold to the room, the glasses starting exploding, one by one, until the table, its occupants and their meals were covered with tiny glass shards.

The Armijo Room is also known for its ghostly piano player. Positioned in the west corner of the room is an antique piano, and several managers and

employees have heard it play by itself late at night. The first recorded story occurred in 1987, when a night manager, alone in the restaurant, heard the antique piano playing in the Armijo Room. Suspecting a burglar, he quickly but quietly made his way to the rear of the restaurant and locked the door to enclose anyone in the house. Then he called the police. With flashlights and weapons drawn, the police completely explored every room in the house. No one was found, and everything was as it should have been.

Daniel Lamb, who was alone in the lobby area doing some work one night, heard a soft piano melody originating from the Armijo Room. He made his way through the darkened house, reaching blindly into each dining room to turn on the lights. When he reached into the Armijo Room to turn on the lights, the music stopped. There was no one present, and the room was completely empty.

The Armijo Room is also a favorite haunt of a ghost that the staff refers to as the "waiter hater." It all began with one employee who didn't like working in the room, where a portrait of one of the members of the Armijo family hangs. The woman has unusual light-colored eyes that really stand out. Additionally, her eyes seem to follow you no matter where you go in the room. For some personal reason, this particular waiter disliked the dining room and especially the portrait of this woman. As he went about his duties, he would often make rude comments about the woman in the portrait, including some rather off-color jokes.

After a while, an obvious pattern began to slowly develop. Soon after he said something negative about the portrait, he would have a mishap of some kind. When this waiter came to the restaurant, he was highly recommended and quite capable. Then he started dropping trays of food, tipping over glasses of water and having other such incidents. Oddly enough, all of these accidents took place directly in front of the portrait in a dining room filled with guests. Things finally came to an end one evening when he was forcibly pushed to the ground as he passed in front of the portrait. To no one's surprise, this waiter left his employment at the restaurant soon afterward.

Next to the Armijo Room is a cozy little dining area called the Sarachino Room, a favorite area for an apparition known as the Lady in the Red Dress. On a day in November in 1993, a waiter had just returned from placing a meal order for a young couple seated in the Sarachino Room. Just before he entered the room, he distinctly heard a woman's voice asking, "Can you help me, sir? I need your help." When he turned to face the direction of the voice, he discovered that no one was in the room. He shrugged it off and continued his walk back to the young couple's table. As he entered the

room, a woman began waving her hand excitedly, saying, "Did you see her? Did you see her?" There was a smell of flowery perfume in the air similar to a lilac scent. The couple then described a middle-aged Hispanic woman with light-colored eyes and dark hair who was wearing a red dress. She had appeared at the doorway leading into the dining room, and as she entered, she paused and just stared at them. Then the woman turned away from them and disappeared into thin air as the waiter approached.

Moving east across the restaurant, one immediately enters the Chacon Room, the home of yet another ghost. One night, while cleaning up a table nearby, an employee was strangely compelled to look into the adjacent Chacon Room. There, in the empty space, he looked at the west wall, where a large mirror is hung. To his amazement, he saw the reflection of the figure of a man in a dark suit seated at the table. The room was more than adequately lit, and he appeared quite clearly in the mirror. Although his image could be seen in the mirror, his image was not visible at the table. He was described as wearing a collared white shirt with a full head of dark gray hair. He kept his arms to his side, he never made a move and he sat at the table quietly, as if he was waiting for someone to join him. The ghost of the man in the dark suit has only appeared to people in the Chacon Room, and most of the employees who have been at the restaurant for a considerable time have encountered the ghost at one time or another.

Continuing on our westward trek, one now enters the restaurant's southeast room, a quaint little dining space called the Zamora Room. This is the room that contains the infamous haunted mirror at the Maria Teresa. The story began when a waitress was taking dinner orders in the Zamora Room for table of six seated directly below a large antique mirror. After taking the orders, she was on her way to the kitchen when suddenly, one of the patrons got up and ran after her.

She was quite excited and asked the waitress, "How do you do that? This is really cool that you provide entertainment for your customers while they wait." Astonished, the waitress replied, "How do we do what?" She followed her customer back to the dining room, where she found the rest of the group seated and happily smiling. Reflected in the mirror next to their table, seated between two of the patrons, was a clear figure of a woman. Although she appeared to be seated between two of the patrons, she did not use a chair. The customers had assumed that it was all a special effect that was provided by the restaurant.

Not wanting to mention that it was a ghost and risking losing her tip, the waitress decided to play along. She agreed that it was a really neat

The 1881 bar where the apparition of a cowboy was often sighted. *Photo by author.*

effect, smiled and continued back to the kitchen to turn in the order. The ghost remained visible in the mirror for the next hour as various employees casually ventured out to have a peek at their unexpected guest. When it came time for the waitress to offer dessert, one of the patrons said, "Look," and everyone watched as she slowly disappeared.

The ghost was described as being in her thirties, with long black hair, and was wearing a white dress with long sleeves or jewelry. Her face was quite slender, and her eyes were a clear hazel. She was very animated, moving her hands and arms regularly, and she seemed to take an interest in each plate of food presented to the patrons. She was very pleasant and seemed to be concerned about how the patrons were being served and cared for.

From the Zamora Room, one turns north and heads across the lobby and into the bar. In 1993, the water pipes underneath the floor of the bar needed to be replaced. A crew of plumbers came in and proceeded to remove the floorboards in front of the bar in order to gain access to the pipes below. Once the boards were removed and the bare ground underneath exposed, the work crew began digging down through the dirt. Within a few minutes,

they came upon a cache of old bones. The bones were various sizes and, from their appearance, must have been in the ground for many years. An employee who was an anthropology major at the University of Minnesota gathered the bones in a box and took them to her professor, who had them examined. They were found to be those of a horse, mixed in with a few human bones as well. Are these possibly the remains of the restaurant's restless occupants?

On October 20, 2000, a guest seated at a table in the barroom saw a man in chaps and a vest standing in the doorway. His wife was unable to see the spirit. The barroom cowboy was also spotted in the same doorway from the same table two years ago. Neither guest knew that the restaurant is haunted.

Next to the bar is the Wine Press room. Flatware and tables have been moved, and unseen voices have been heard within this area. The Lady in the Red Dress has also been briefly seen in this room as well.

Rating: Probable

The strangest experience that I ever had at the Maria Teresa Restaurant occurred in August 2000. I was doing an investigation to capture the location on video for a series of television shows for Channel 27, public access, in Albuquerque called *A Ghostly Presence*. I met with the film crew in the Baca Room, where we ate lunch and discussed ideas for the project. The room itself had several suspicious readings that registered on the EMF detector. Several waitresses told us that silverware and plates were mysteriously moved around overnight after they had been carefully placed the night before. They also spoke of several cold spots that moved about this particular area. The room was searched thoroughly for any natural explanation of the EMF fields, but nothing conclusive could be proven either way. The origins of the EMF fields in this area are still quite a mystery. We decided to begin an investigation in the Armijo Room.

This investigation was quite different from ones performed in the past, as we also had a psychic, Sarah Chaplin, who assisted us in locating any spirits. At the request of Channel 27, she held an impromptu séance in the Armijo Room itself. Upon entering the room, I immediately picked up an odd electromagnetic field near the antique piano in the corner of the room and attempted to determine if the fields were of any natural origin. I could not locate any possible explanation that would cause this steady field. I backed up near the door leading into the Baca Room and took a single photograph. The results were most interesting, as it is the only "phenomenon" that was captured on the entire role of film. For the séance, all of the drapes of the

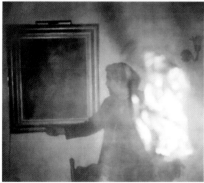

Top: The piano in the Armijo Room that reportedly plays by itself. This photo was taken during the filming of *A Ghostly Presence* for Albuquerque Public Access TV. *Photo by author.*

Bottom: An unusual image captured on 35mm film near the 1881 bar. The picture in the background is of Salvador Armijo. *Photo by author.*

windows were drawn to make the room as dark as possible so we could capture any possible activity with the infrared camera. The producer of the television show also witnessed an interesting occurrence after the séance was finished. She noticed that the sheet music on the piano was changed to a different page and was moved off center from its original location. The room was monitored the entire time, and no one recalled handling the sheet music itself.

However, the strangest of all events happened three days after the film shoot. The manager came into the restaurant that morning only to discover that all of the plates and silverware on the table in the Armijo Room had been pushed up into one large pile in the center of the table. The "Do Not Touch" sign that normally sits on top of the piano had also been moved and had been placed on top of the pile of dishes. If that was not enough, the chairs in the adjoining room, the Sarachino Room, had been stacked on top of one another and moved in front of the passage connecting the two rooms, forming a physical barrier.

During investigations here, SGHA members witnessed the silverware moving in the Armijo Room and captured several interesting EVPs and other abnormalities.

Updates: The Maria Teresa Restaurant has closed, and another business now occupies the site. The owners do not believe that the building is haunted.

CHAPTER 14

ALBUQUERQUE JOB CORPS CENTER

According to city records, for a time during the 1800s, what is now the Albuquerque Job Corps Center was once a convent that cared for small children. In 1918, the Sisters of Saint Francis established an orphanage in Albuquerque. The orphanage was called the St. Anthony Home for Boys, and the nuns cared for the children until 1971, when the Department of Labor took over.

According to local lore, there was a nun known as Sister M who went insane and began to randomly kill some of the children. Afterward, she tossed their bodies into the property's well. It is reported that the current residents at this center today can still hear the cries of children and often see a spectral woman. In fact, several bodies of small children were discovered when the residents of the modern center were installing a swimming pool on the property where the old well was located. Although much of this sounds like an urban legend, the students I have spoken to honestly believe that the area is indeed haunted by spirits. One recent resident provided the following account of one such encounter:

> *Late one night I was awakened by the sound of my door opening and someone entering my room. I got up, turned on the light and looked around. Nobody was in the room or the bathroom. Thinking that I had just been dreaming, I then turned off the light, only the light would not turn off! The lights dimmed to about 50% luminosity even though the switch was completely off. The lights in this bathroom never did this before, nor did they ever do it again!*

The St. Anthony Home for Boys, now the Job Corps Center. *Courtesy of the Library of Congress.*

After that first incident, I always felt eyes above and behind me, looking down from the corners of the ceiling. Things would go missing or be moved. At the time, I was a fair artist and an avid reader. I'd literally just put down a pencil for a second, and it would disappear. Books would vanish and reappear in other parts of the room, sometimes months later. I'd hear my name called and catch flickers of movement out the corner of my eye. After dark was the worst. I was scared to sleep sometimes, scared of not knowing what was going on around me or not knowing why no one else seemed to experience the things I was. I kept that closet door shut and my door locked, but that didn't help much either.

One night, my girlfriend and I had the room to ourselves. We were snuggled on a bed watching videos on my small television. She observed that it was really cooling down outside, because she felt a cold draft. I felt fine, but took her comment as an invitation to cuddle closer. A few minutes later, she complained she was freezing, so I got up and turned off the air conditioning. I asked her where she felt the draft coming from, and she gestured toward the other bed. We both glanced over at the same moment, and I felt every hair on my head stand straight up. There, on the other bed, the mattress was sagged down as if under the weight of a full grown adult.

She ran for the door, and I was right on her heels. She didn't stop for two blocks, and nothing could convince her to go back in the dorm, especially after I confessed some of the other things I'd experienced since moving there. My girlfriend stayed with me despite her scare. I thought for sure that she would dump me.

There is also another account from another resident who is skeptical of all things that are said to be paranormal. He attests that once he distinctly heard children playing in the other half of the house. When he got up to investigate, the sounds stopped. There were absolutely no kids around outside, nor were there any inside. He was completely alone.

Rating: Improbable
Out of all of the places in Albuquerque, this is the only one I have not investigated. I gave this an improbable rating because there is not enough data for me to make a determination. I have not located any sort of historical reference that indicates any murders ever happened at the orphanage.

CHAPTER 15

LAS MAÑANITAS

L as Mañanitas" is a folk song of celebration that is traditionally sung on a person's birthday or Saint's Name Day. There is no written record of when the same-named adobe structure standing on the northwest corner of present-day Indian School and Rio Grande was built. Legend and word of mouth has it that sections of the building are more than three hundred years old.

It has been remodeled over the years to accommodate its several owners, but evidence of its age is still readily apparent. The changes made by the many owners over the years are part of the reason it is a landmark. The varying roof heights, multiple patios and rambling features of the house are extremely significant because they illustrate the history of the house through its owners.

Current residents of Duranes, the old farming community surrounding Las Mañanitas, remember their grandparents recalling that the building was a stagecoach stop on the road through the valley to Santa Fe, El Camino Real (including sections of Rio Grande Boulevard). It also operated as a pool hall and a bar, and there are tales of exuberant bailes (dances) held in the large sala (living room). The Speronelli family owned the house and land at the turn of the century; they had a blacksmith shop, and iron artifacts from the shop have been found on the property. Later owners added rooms, which were eventually joined together into a harmonious whole.

Despite changes to the house, many architectural features remain from its early days. A thick dirt roof lies beneath the standard tar and gravel roofing.

The courtyard of Las Mañanitas. *Photo by author.*

The massive walls are made from terrones, sod blocks cut from marshes along the river. The depth of the walls is clearly seen in the low-set windows (some only a foot or so from the ground) with their deep reveals. Within the building, original round hand-adzed vigas (roof beams) support the sala roof, and corner fireplaces warm several of the rooms.

Paul and Linda took over Las Mañanitas in 1991. Before Paul and Linda, it was a restaurant operated from 1985 to 1990 by a previous Albuquerque mayor. Before becoming a restaurant, the property was owned and used as a residence by Sheila Garcia, the Kinney family, the Harrison family and the Gilstrap family. Neighbors and previous owners have told Paul and Linda some of the events and history of the building. At one time, there was a farm and a blacksmith located on the property as well. Neighbors would hear the bang and clang of the blacksmith at work.

Original wooden ceiling beams and kiva fireplaces still exist. When the building was renovated in 1991, more than five tons of dirt were removed from the original sod roof. There are light fixtures in many rooms and medicine cabinets in both bathrooms that were saved from the Hotel

100

Alvarado, the famous Albuquerque fixture. (The Alvarado stood from 1896 to 1945.)

Paul and Linda were told when they took over the restaurant in 1991 that it was haunted. In their fourteen years at Las Mañanitas, Paul and Linda have witnessed and been told firsthand of several occurrences. There does not seem to be any pattern. The building will be quiet for months at a time, and then there will be a flurry of unexplained activity for several days in a row.

Reportedly, one previous owner, Mrs. Kinney, was plagued by what she thought were "evil spirits." She stated that plates flew out of the oven at her and that the doors inside the building would slam shut after she walked through them. The slamming doors unnerved Mrs. Kinney so badly that she had all of the interior doors removed, and to this day they remain stacked in the garage. Supposedly, Mrs. Kinney brought in members of the church to perform an exorcism, to no avail. Wait staff employed when Paul and Linda took over the restaurant told them to be sure that they "left toys out for the kids." They were told that the ghosts of a boy and a girl were often seen playing out on the patio or were heard playing in the house. Linda leaves toys in hidden areas of the building and then returns to find that they have been somehow broken.

One evening after closing, Paul entered the dining room to find the metal chandelier swinging wildly back and forth. All of the windows and doors were closed in the building, the heat and air conditioning were turned off and there was no breeze or air flowing in the room. Paul called for Linda to come look. When Linda entered the room, she also saw the chandelier swinging from side to side and asked Paul, "What are you doing?!" Paul stated, "I did not do a thing! It was moving when I walked in!" They could not explain the chandelier's movement.

Guests seated in the main dining room have witnessed "something flying in and out of the fireplace." Witnesses stated that a "cloud" or "ball of smoke" shot out of the fireplace and then moved extremely fast into the center of the room, where it dissipated in front of everyone's eyes. One of the guests asked afterward if they could perform a séance in the room, but their request was denied.

Paul and Linda's cat often runs throughout the building as if it is playing with someone. It looks like it is chasing someone or being chased.

Several times, Paul and Linda heard what sounded like a squeaky rocking chair rocking bath and forth in what is now their office when no one was in the

room. A few months later, a psychic visited Las Mañanitas. She asked if she could look around, as she felt the presence of "spirits." She walked into what is now their office and told Paul and Linda that she saw a "sewing room with a rocking chair." The psychic also stated that she felt that a man was hanged in one of the older back rooms of the building. This is the only mention Paul and Linda have ever heard of a murder or death in the building. The hanging cannot be proven, but Paul and Linda state that "given the building's sordid past, it would not surprise us if it were true."

The lights go on and off at random. In one instance in particular, Paul noticed that the lights in the main dining room were turned off. He went and checked the light switch, which is a round dimmer-type of switch, and found the switch still turned on. Paul turned the switch off, leaving the lights off, and left the room. A few moments later, Paul looked at the dining room and noticed that the lights were now on. He checked the dimmer switch only to find it still in the "off" position. He left the lights on and left the building.

The building is made of adobe and retains heat extremely well. In fact, on a hot summer's day, the temperature inside can be quite unpleasant. But at times, the staff will walk through what they describe as unexplainable "really

An unusual mist captured on camera during a daytime investigation. *Photo by author.*

cold spots." One winter's morning, Paul and another employee arrived at work, driving across the virgin snow, almost four inches high, in the parking lot. They were the first to arrive that day. The ground was beautiful with the untouched coating of fresh snow. As they entered the gate to the courtyard, they noticed very large footprints in the snow in front of them, walking in a sort of oval route toward the house. However, the tracks seemed to just start and stop with no visible trail leading to or away from them. Paul said that the footprints were "huge—at least a size fourteen," and that it was "almost as if the person had been placed then lifted off the ground and disappeared."

One busy afternoon, Paul and an employee were frantically cooking in the kitchen. One of the waiters reported to them that they were out of clean coffee cups. The sounds of the dishwasher running and the rattling of dishes could be heard coming from the sink area of the kitchen. Paul assumed that Linda was in back washing dishes, and he was a bit upset that she was not out waiting on customers. Just then, Linda walked into the kitchen from the dining room. Paul and the employee both asked, "Well then, who is back there doing the dishes?" All three of them heard the noise and rattling coming from the back. They went to look, but no one was there. However, they found that all of the coffee cups had mysteriously washed themselves and were drying in the rack.

Customers often ask, out of the blue, if the building is haunted. They state that they "feel" a presence and that they "know" it is haunted. Once, a male customer sat out in his car for more than an hour and would not join his wife inside for dinner because he felt so uncomfortable.

A professional photographer named Ms. Allencort once visited Las Mañanitas. She took a few pictures around the property. A copy of one of these photos now hangs in the hallway. The copy was sent to Paul and Linda from a Wisconsin art gallery, where the original photo is on display. Many people report seeing the faint, hidden image of a grandmother and a cat in the photo. Allencort returned to Las Mañanitas several times, attempting to take more pictures. However, every single photo she shot on subsequent visits never turned out; these photos were completely black. Paul and Linda believe that there are two main ghosts who haunt Las Mañanitas.

The first is a woman whom they call "Priscilla." Paul and Linda both state that they can feel her presence. "You know when she is here," they say, "because you can smell her perfume throughout the entire restaurant." The building will be closed with only them in it, and the strong, overpowering perfume will fill the air. At other times, customers have even complained about the strong smell.

The second shot showing the movement of the mist. *Photo by author.*

A mariachi who often played in the restaurant stated that he once entered the back dining room and saw a woman in a big fancy white dress. He looked away for a moment, and when he looked back, she had vanished. A busboy once saw a blond-haired girl wearing a plaid-colored sweater enter the men's bathroom. The busboy waited and waited for her to exit the bathroom. He knocked on the door and got no answer. He tried the doorknob, but it was locked. He waited outside the door for almost an hour and then knocked and tried the door again. Now the door was unlocked, and when he entered, he found the room empty.

The second ghost is that of a large young man. "He is very, very big," states Linda, "but you can tell he isn't that old; he's a young man." He is often seen out of the corner of her eye, and Linda often mistakes the shadow for one of the waiters. She will see someone walk by and will call out to whoever she thinks it is before she realizes that no one is really there. Often Linda and other female employees will feel a light breeze blow by them, and then they feel the touch of fingers on their hips, a friendly and flirty sort of gesture. They will turn around to see who is behind them, and no one

will be there. Linda even tells the new female wait staff in advance "not to freak out" if this happens to them. One time, a customer felt a hand on her shoulder. When she turned around, no one was there.

The young niece of a frequent customer said that she often talks to "someone" while in the bathroom of Las Mañanitas. The girl states, "A boy is in there under the floor. He talks to me." When asked how she talked to this boy under the floor, she just said, "I don't know…but we communicate." The girl had never heard any of the stories about the shadow of a young man seen in the building. One afternoon, the young girl ran out of the bathroom squealing in excitement. "He told me his name! He told me his name! His name is Joaquin!"

It is believed by many that Priscilla, the woman seen in the fancy white dress, once worked in the brothel that is now Las Mañanitas. Priscilla became pregnant and had her child on the premises. Sadly, Priscilla died while giving birth to her son, Joaquin. To this day, Priscilla wanders the halls looking, in vain, for her son, just as Joaquin still searches for his mother.

Las Mañanitas is not in Old Town proper; it lies several miles north of the plaza. I have included it due to its age and proximity to Old Town.

Rating: Plausible

One of the most common questions asked when someone finds out that you are a ghost hunter in Albuqerque is: "Have you been to Las Mañanitas?" The sheer number of people asking if I have investigated the restaurant is staggering. Many of them have had their own experiences.

During SGHA's investigation of the location, we located several abnormalities: three electromagnetic fields with unusual frequencies that would appear and vanish, positive and negative ion counts that didn't make sense in their concentrations and a multitude of EVPs. What makes the EVPs outstanding is that we used two audio recorders of the same make and model on a table twelve inches away from each other. The EVPs hit one recorder but were absent on the other. The addition of the second recorder acted as a control and eliminated explainable noises as possible causes for the phenomena.

CHAPTER 16

JULIA'S NEW MEXICAN AND VEGETARIAN CAFÉ

Don Luis Plaza in Old Town

Julia's New Mexican and Vegetarian Café sits on the far west end of the Don Luis Plaza in Old Town. This was the location of the first church built in Albuquerque.

The original church of San Felipe de Neri was started in 1706 under the direction of Fray Manuel Moreno, a Franciscan priest who came to Albuquerque with thirty families from Bernalillo in 1704 or 1705. The building was erected on the west side of the plaza, with its entrance facing east. Unlike the present-day church, the 1706 building was oriented toward the east in order to take full advantage of the theatrical effect of the rising sun shining on the altar. The church was initially named San Francisco Xavier by Don Francisco Cuervo y Valdez, who founded the city of Albuquerque and named it after the viceroy of New Spain. The Duke of Albuquerque ordered that the titular saint be changed to San Felipe de Neri in honor of King Philip of Spain.

A written account in the year 1715 chronicled a convicted criminal en route to exile (in El Paso) who took sanctuary in the church. By 1718–19, the first church was completed. It stood on the west side of the town plaza, north of the current Basket Shop. The cemetery was located east of the church and was enclosed by a rather high adobe wall that had three gates for access. The convento (rectory) was to the south. During times of attack by hostile nomadic Indians, the church was used as a fortress where women and children could be locked inside.

Don Luis Plaza, the location of the first graveyard in Albuquerque. *Photo by author.*

The fate of the original San Felipe is not documented, but in about 1790, rains and a possible flood reduced the church to an unusable condition. Work on the new church was started at another site, just to the east, and this one had a north–south orientation. It was completed in 1793, and this is the building that still stands today, making it the third-oldest church in North America.

In 1869, the Jesuit Fathers in Albuquerque announced they would be building a new chapel and a new cemetery as the old cemetery near the San Felipe de Neri Church would no longer hold burials. Father Donato Gasparri found a better site three miles from the Old Town site. The majority of the bodies from the old grounds were carefully moved in 1869. The key word here is "majority," as not all of the bodies were removed. This was mostly due to the fact that graves in the late 1800s were often marked with wooden crosses or even a simple pile of stones. If those were disturbed or withered away by the elements, the locations of the graves were lost.

Over the years, coffins have been accidentally disturbed during excavations for water and sewer lines and other such modifications. Indeed, there may be several coffins still resting under the brick and pavement of Don Luis Plaza. After all, we are talking about 163 years of burials that would have taken place at the original cemetery.

The building that houses Julia's café is a rental property, and the former tenant, Mama's Fry Bread, was also plagued by paranormal activity. The apparition of a woman has been seen standing in the northwest corner of the dining room, watching the guests and staff. The unusual thing about her

is that she can only be seen by certain people, particularly women. Couples dining at the café have had the female guest see the woman while her male companion was unable to see anything.

The kitchen also has its share of ghostly encounters. Eerie sensations that you are being watched are often accompanied by strange gusts of cold air that seem to originate from the storeroom. These blasts of cold air often startle the employees but are also welcome during the summer months.

The building was badly damaged in a fire, but the structure stayed intact because of its thick adobe walls. The building was repaired and rented out again to become Julia's. Just after the opening of the café, a psychic visited the building and told the owners that she believed that the building was haunted. She also mentioned the "ghost woman" in the northwest corner of the dining room, although no one at the café was able to see it.

The area just in front of the café is also relevant because it was the location of the first sighting of a rather nasty apparition that local ghost hunters have nicknamed "Grim." The witness was a security guard who was going to his office, located just north of the café. His story is recounted here:

> It was around 11:00 pm. I was on my way back to the office to finish some paperwork for the evening when I decided to take a cigarette break. I placed my coat on top of one of the wrought-iron tables that grace the Don Luis plaza.
>
> I lit up and turned around to see a gentleman back in the corner of the café patio. His back was turned to me, and it appeared to me that he was urinating on the building. I yelled at him and quickly turned to pick up my coat. I had a canister of mace in one of its pockets, and I wanted that handy just in case this fellow got a bit rowdy.
>
> When I turned back around, no one was there. It would be impossible for someone to leave the area that quickly; I would have seen or heard them go by. I rubbed my eyes for a few seconds and started doubting myself. Did I really see someone there? I went over to the area where the figure had been and was turned away by the foul smell of decaying flesh. At the end of my shift, I reluctantly returned to the patio. I was worried that there might be a dead animal in the area that needed to be removed before the tourists arrived in the morning. With my mace in hand, as if that would do any good against a ghost, I approached the patio and thoroughly searched it. The foul smell was completely gone.

Other sightings of "Grim" are not as meek. An Albuquerque police officer was on patrol when he sighted a similar figure near the Basket Shop on Romero Street:

I was patrolling the area near Old Town around 3:30 in the morning. There had been several attempted burglaries in the past several weeks, so we were watching the area more closely. I was heading south on Romero Street when I spotted a tall male standing near the front window of the Basket Shop. He was dressed in a black trench coat or duster and was wearing a black cowboy hat. His back was turned towards me.

I stopped the patrol car and fixed the spotlight on him. The man did not react as I got out of the car and informed him that Old Town was closed and that he had no business here this early in the morning.

The figure turned and grimaced at me. His facial features were very strange, almost skeletal in a way. Then he gave me the "one finger salute," turned and walked through the west wall of the Basket store.

I stood there for a minute, quite confused about the whole situation. Had I just seen a ghost?

Grim has also been known to shout obscenities at other people who have been unfortunate enough to see him, making him the most unpleasant ghost in Albuquerque. In fall of 2004, a group of tourists had an encounter with Grim behind the hacienda patio when it mistook him for a guide for the Old Town ghost tour.

The sighting had similar elements to the aforementioned encounters in that the ghost was turned away from them and the witnesses were unaware that the "person" was a ghost until he turned around. Again, the stench of decaying flesh was smelled as the ghost shouted at them, in a very rude and obscene way, to leave him alone. The tourists fled.

There are many theories on who the ghost may be. Some speculate that he is the ghost of the Wild West outlaw called Scar Face Charlie. Scar Face was a gambler and con man who visited Albuquerque often during the late 1800s. Such characters were known to hide their money by burying it in small hoards to prevent them from being robbed. Did the museum or another Old Town merchant disturb one of Charlie's stashes, thus bringing his ghost back to search for the missing loot? The next suspect is Milt Yarberry, Albuquerque's first sheriff. He was hanged for murder in 1883 in the courtyard of the old jail, which is now the Old Town parking lot on Central Street. Another possibility is that the ghost may be the lawman and gambler Jack Helm, who was brutally murdered by John Hardin, another infamous outlaw of the Southwest.

Rating: Improbable

While we cannot discount some of the witness sightings, SHIELD has identified "Grim" on two occasions as being the author himself. I had a habit of walking around Old Town drinking a cup of coffee after conducting a tour to unwind and chat with friends.

This was discovered when SHIELD's director was looking for me one evening and eventually ended up following a group of tourists after they had taken the tour. The tourists were attempting to take a shortcut back to their hotel when one of them spied me from a distance. After making a remark that it was one of the "ghosts," they fled. We received an e-mail from them the next day describing their encounter with "Grim."

This ghost story really hinges on the testimony of witnesses. As I have already shown, some of that testimony can really be unreliable. The ghost tour was meant to be scary and fun, and many of the witnesses who claim to have seen Grim may have become more susceptible after hearing an hour and a half of ghost stories.

The most convincing evidence is that of the police officer, but are we really dealing with the same phenomenon? So far, all attempts to obtain some form of evidence have been for naught. Until something more tangible arises one way or the other, I'm just giving this one the benefit of a doubt.

CURIOSITIES

Most ghosts seemed to be confined to a particular location, such as a building or graveyard. Grim is unusual in that he has been "seen" in areas all over Old Town. The majority of the sightings have been at or near the Don Luis Plaza, but he has also been reported near the chapel north of the plaza and over near the hacienda patio to the east.

An artist's rendition of "Grim." *Courtesy of SGHA.*

In 2004, SGHA members were looking for a new mascot when the sighting involving the police officer occurred. His description of Grim was taken to an artist, and after a few modifications, it became the SGHA mascot (so to speak).

CHAPTER 17

THE MANUEL SPRINGER HOUSE

The Manuel Springer House is a historical two-story brick Queen Anne–style building that now houses the Covered Wagon and several other shops in the Old Town Plaza of Albuquerque.

Rumors and folklore claim that the building was once used as a speakeasy and brothel during prohibition. Additionally, the building is believed to be haunted by the ghost of a prostitute named Scarlett Torres. According to the legend, Scarlett and another unnamed prostitute got into an argument over a wealthy client on the stairs of the building. The argument turned violent and ended with Scarlett being stabbed in the stomach. She died on the stairs from blood loss before medical assistance could arrive. Because the building was a speakeasy, the local law enforcement was paid off, and the murder was believed to have been covered up. This is why she supposedly haunts the building. The ghost of Scarlett is supposedly seen on the balcony and in the rear alley behind the building. It is interesting to note that the alley behind the Covered Wagon shop was once Morris Street.

The most spectacular sighting occurred in June 1998. Late one evening, about thirty people were in the plaza when they noticed a woman walking on the balcony of the old Springer House. She was completely nude except for a garter that was on her right thigh. Since there were children in the plaza as well, several of the men yelled up at her to put something on. However, she was oblivious, as if she didn't hear them. Then, as they all watched, she turned and walked through the wall on second floor. It

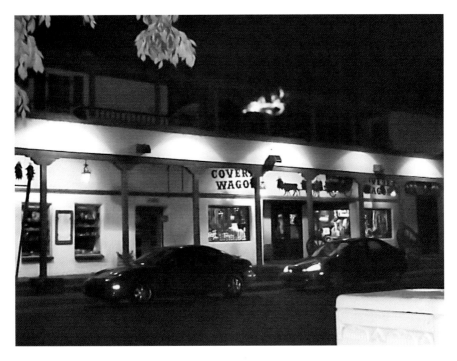

The Covered Wagon, once the Manuel Springer House. This is a ghost photo that was debunked. (It is nothing more than an airborne cottonwood seed.) *Courtesy of SGHA.*

would seem that they were not yelling a living person but rather the ghost of a long-dead prostitute.

Over the years there have been numerous sightings. I have compiled them here.

FIRST SIGHTING

July 9, 2005
From a Ghost Tour Guide

> *We had another possible sighting of Scarlett, this time on the tour. I had just purchased a new DVD player for the tour and was using it for the first time on Saturday. When we were behind the Covered Wagon, I started up the DVD player, and it started messing up. There was a garble of voices,*

one that sounded female, coming from the DVD player, and the picture was going haywire. I was not thinking ghost at the time; I was pissed because I just bought it and now it is not working.

Anyway, while I was tinkering with it, the doors pulled back, as if someone was behind there trying to pull them open. One tug and that's it. I really didn't pay much attention to it, once again because of the DVD player. So I turned the DVD player off, finished the bit without it and off we went to the Bottger Mansion. The DVD worked fine there.

On the way back, we were turning on Old Town road going back to the Hatchet Lady area. As I turned, I saw a woman down at the far end of the alley, wearing a short dress thing. It appeared to me that she was smoking a cigarette. I was still talking about the old courthouse, and I blew it off. I thought that it was probably a waitress from Antiquities taking a smoke break.

Suddenly, someone in the tour (I had a group of twenty-seven) shouted, "Hey, there is a woman back there with a purple dress on!" and couple of folks with 35mm cameras started taking pictures.

Okay, I didn't notice the color. I looked again, just as she moved back off toward the right, and yes, the dress was purple. Still might be a waitress, but two younger guys on the tour asked if they could go and have a look real quick. I said it was cool and that it was probably a waitress, but off they went anyway.

A few minutes later, they came back. They said the "doors" were still locked. They also knocked on the back door to the restaurant, and no one answered. The cars in the alley were gone as well.

So I changed the tour route, and we went straight, in front of La Placita instead of behind it. The Covered Wagon was empty and locked up. After the tour was over, I fired up the DVD player, and the Springer House bit worked fine.

Thinking about it, I had always visualized Scarlett's dress as a long ankle-length thing, not as a short, tight-fitting, mid-thigh ensemble.

SECOND SIGHTING

August 7, 2004
From a Ghost Tour Guide

Last night, July 6 around 9:50 p.m., I received a call on the NM Ghost Tour line from two very excited and freaked-out individuals concerning

something "possibly paranormal" that had just occurred in Old Town. The problem was that they were too excited and talking too fast to really understand what exactly they were carrying on about. They were tourists from California and were desperately trying to get me to come to Old Town. I informed them that I was in Socorro, and upon eventually discovering that they were traveling to Las Cruces via I-25 the next day, we decided to meet up at the Socorro Denny's for coffee. Fortunately, we were able to get that set up as our conversation was cut short by static as their cell was cutting out.

The next day, I met them and we talked for about an hour and a half, putting the pieces together, before heading back over to my place for a while. Putting the story into a narrative context, here is what happened. Joel and Rodger (both in their mid-twenties) had originally planned on taking the ghost tour, but due to complications, the tour was cancelled for that night. Rather than heading back to the hotel, they decided to do some skateboarding around Old Town. They were parked in front of the old Manuel Springer House, the brothel from the Prohibition era, so the car was close by.

After retrieving their skateboards from the trunk of their car, they were approached by a woman asking for money. They gave her "a few bucks," and she wandered off. Rodger remembers that she was quite well dressed for a homeless person and made a comment to his buddy that she was probably a "whore looking for drug money."

They were cruising around Old Town for about thirty minutes or so when Rodger's shoestring became tangled in one of the skateboard wheels. They stopped underneath the portal at La Placita so he could untangle it and retie his shoe. This was when Joel noticed a "very attractive" woman wearing a "form fitting and low cut" purple dress across the street in the alleyway just south of them. She smiled and waved at them before turning and heading back up the alley (old Morris Street).

Naturally, being twentysomething males, they chose to pursue and find out who this young lady was. After Rodger got his shoe untangled and tied, they crossed the street and entered the alley. (Both guys estimate that there was about a twenty- to thirty-second delay due to the shoestring issue.) When they entered the alley, the young woman was on the far end. She looked back over her shoulder and motioned for them to follow her, which of course they did. She then moved off to the right side of the alley and out of sight. They moved up the alley and turned right at the only place that they could, the passage to the back door of Antiquity's restaurant. There was no one there.

They were about to knock on the door when a woman's voice called out from behind them.

"Hey! Over here!" So, they turned around and walked toward the direction of the voice. Still not seeing anyone in the area, Joel called out, "Where are you?"

"Back here," the voice replied. "Come on inside." The woman's voice came from behind the two large wooden doors at the back of the Manuel Springer House, and there was an extremely strong floral scent in the air near the doors. Rodger attempted to push open the doors, but it seemed like they were bolted shut from the other side.

"We can't get in, the doors are locked," he said to the woman on the other side. There was a scraping or cracking noise on the other side of the doors, followed by a "mechanical" sound. Rodger moved to push the doors open when suddenly they violently swung outward, hitting him in the shoulder and knocking him to the ground. Joel, standing back away

The alley behind the Covered Wagon. Once known as Morris Street, it is the birthplace of several local legends. *Courtesy of SGHA.*

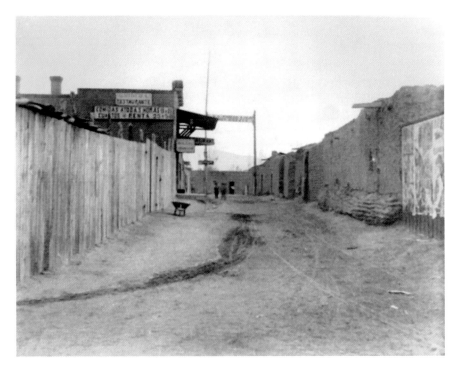

Morris Street looking west, sometime about 1890. *Courtesy of the Library of Congress.*

from the doors, felt a cold rush of air as the doors burst open, slamming into the wall with a loud pop. There was no one behind the doors, and the area was vacant of any living person.

The doors swiftly closed again and immediately burst open with the same force as before. This time, one of the doors hit Rodgers left leg as he was scampering to get away. However, when he looked through the open doors, he saw a rotten corpse in that same purple dress, with blood gushing out of its side. The doors were covered in blood, as was he. Needless to say, he went into extreme freak-out mode. The doors repeated this opening and closing bit one final time as Joel ran from the area, followed by a limping, very terrified Rodger. They didn't stop running until they were back in the plaza.

For the next several minutes or so, Joel helped Rodger calm down. He was not actually covered in blood, but he was injured. Joel wanted to go back and check out the alley again, but Rodger would have no part in it. That is when Joel remembered the ghost tour brochure in his back pocket and called me.

THIRD SIGHTING

July 1998
Various Sources, Heard Secondhand

According to several witnesses, a nude redheaded woman was seen walking around on the balcony above the Covered Wagon shop (old Springer House) during the annual fiesta in Old Town Albuquerque. Many of the spectators claimed that she was either high or "out of it" due to the fact that she seemed to ignore their comments. The local police were called, but the woman walked into a doorway just before they arrived. A subsequent search of the area revealed that no one was there.

Rating: Debunked

The catalyst of the ghost story is the handwritten police report of Scarlett Torres's death. Near the top of the report, "106 James" was sloppily written, possibly indicating an address. Since South Plaza Street was once James Street, this seemed to correspond to the location of the old Springer House. However, in 2005, the actual investigation report was found in the historical

An artist's rendition of the ghost of Scarlett. *Courtesy of SGHA.*

achieves. The number 106 was the responding officer's badge number, and James was the last name of that officer. The murder itself occurred at the Centennial Hotel that once stood on Rio Grande Street. The full report also states that Scarlett was a social worker and not a prostitute. Since the murder did not occur at the old Springer House, there is no catalyst for her "ghost" to be there.

SKEPTICAL REVIEW OF THE FIRST SIGHTING

The first sighting was debunked by SHIELD one week later by questioning employees of the Covered Wagon shop about "paranormal" occurrences. During the questioning, one of the employees admitted that she had been having a cigarette break after taking out the trash when she noticed a large group of people staring at her from the end of the alleyway. She put out the cigarette and returned inside the shop. She was wearing a short purple ensemble (although it was not that of a 1920s flapper), and the incident had occurred about a week earlier.

SKEPTICAL REVIEW OF THE SECOND SIGHTING

The second sighting was debunked by SHIELD two days after it occurred. Since the call came to a cellphone, it was logged in the cell's incoming call list. The SHIELD director called the number, pretending to be a representative of the press. Since the "bruise" would constitute physical proof of their story, he asked if he could fly out and have the bruise looked at and verified by a medical professional. Joel admitted that their "ghostly encounter" was faked.

The bruise was done with makeup (eye shadow), and they did it because they were upset that the tour had been canceled that night. The young man also stated that he thought it would be funny to "get even" by fooling the ghost tour guides by making them think that they missed a sighting of one of the ghosts. After this reveal, the author ended the Scarlett ghost story by remarking, "It is an awful lot to go through to pull off a hoax, so decide for yourselves." This line was either forgotten or not used by other guides doing the Old Town ghost tour.

Additionally, the doors do indeed open inward. It is physically impossible for the doors to open outward without causing significant damage to the door jam. The doors would most likely be pulled off their hinges if the doors were forced outward.

The doors in the alleyway behind the Covered Wagon where the ghost of Scarlett supposedly appeared.

SKEPTICAL REVIEW OF THE THIRD SIGHTING

The third sighting was explained by examining the police records from 1998. A homeless woman (name withheld for legal purposes) was arrested for indecent exposure on Saturday, July 6, at 11:34 p.m. near Rio Grande Boulevard and Central. She was only wearing pantyhose and admitted to climbing up on the balcony of the Covered Wagon by scaling the wall and then up to the roof on the west side of the building. The woman was also thought to have had a mental illness and had not been taking her medication. This places her near the location and the proper time to explain the balcony sighting. It is also curious that none of the locals in Old Town reported seeing this "ghost."

CASA DE FIESTA RESTAURANT

THE CRISTOBAL ARMIJO HOUSE

2004 South Plaza Street

This historic house is thought to have been built in 1840 by the Zamora family. Originally, the exterior was made to look like brick, the more modern work having been completed by Florencio L. Chavez after World War II. Early photographs of the house reveal a truncated hip roof; however, the roof was later flattened during the puebloization of Old Town in the 1950s and '60s. At the time of its construction, all of the present-day amenities were included. A small basement contains a boiler, and small trenches were dug to accommodate piping and ventilation ducting.

During the Civil War, the building was used to house some of the Confederate soldiers who remained in Albuquerque during Sibley's march to the north.

Little is known of the life of the Armijo family (who later lived here) in the old two-story building, although several interesting legends remain. One states that Cristobal Armijo periodically hid money in the walls of the house and that once a year he would dig it out to deposit it in a bank in Chihuahua, Mexico. Another states that there is a secret tunnel under the house that leads to La Placita, across the street.

Behind the building is a modified adobe corral with a zaguan entrance that probably dates back to the early days of the home. Historically, the site has also been used as a butcher shop, a jewelry store, a general store and eventually a restaurant. Before the construction of the

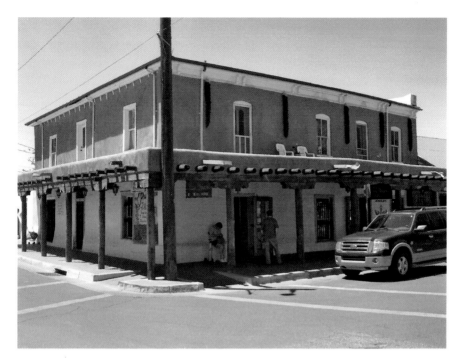

The Casa de Fiesta restaurant, formerly the Cristobal Armijo House. *Photo by author.*

South Plaza Street, circa 1900. The Cristobal Armijo House is on the far left of the picture. *Courtesy of the Library of Congress.*

house, members of the Armijo family had a house constructed near the same location.

Employees of the restaurant believe that it may have a ghost. Their typical otherworldly encounters include disembodied voices that are often heard in the rear dining room and in the restrooms; kitchen appliances that seemingly turn on by themselves and are often found in places where they were not left; sudden, strong changes in temperature in the dining areas; and unexplainable noises coming from the trapdoor in the main dining room.

Rating: Debunked

SGHA was able to replicate all of the reported activity at this location. I noticed that the ventilation ducts could easily transmit noise from one location of the building to another. The ductwork, which is quite visible, extends out of the kitchen and follows the hall back toward the bathrooms, ending in the women's restroom. Branch lines of the duct lead off to the rear dining room and the men's restroom. The hypothesis was tested with Bob making noises in the kitchen. The noises could be easily heard in the bathrooms and the rear dining room, although the sounds were slightly different in each location due to the transmission through the ductwork.

From here, we moved into the main dining room. We inquired if the trapdoor had ever been opened and examined to see if a cause of the odd noises was ever investigated. We were told that it hadn't. The trapdoor had been waxed over several times, and it appeared to be stuck.

So, after acquiring a pry bar and exerting a lot of effort, we were finally able to open the trapdoor. The area below was a large crawlspace, about three feet in width and four feet high, and could probably be more accurately described as a tunnel. After several minutes of looking into the space with a flashlight, I entered the tunnel to investigate.

The tunnel itself had several inches of lime on the floor and extended northward toward the front of the building for about fifteen feet. At this point, it turned and headed east. As I traveled down the east section, the floor began to rise until the crawlspace was impassable. In this location, I found huge deposits of bones covering the floor, at least one foot in depth. As I backed out of the tunnel, I noticed several water pipes secured to the floor above with banding material that was extremely loose. Several times on the way out, I accidentally bumped into one of the pipes, causing it to bang on the floor above.

Upon exiting the tunnel, I was informed that the group above had heard the noises that the customers and staff experienced. I told them about the

Looking east down South Plaza Street, circa 1900. *Courtesy of the Library of Congress.*

loose pipes and the bones. After several minutes, I reentered the tunnel with a Ziploc baggie and a screwdriver. The loose screws were tightened, and samples of the bones were taken for a professional analysis. The bones were determined to be goat bones, about two hundred years old. That would jive with the fact that the location was once a butcher shop, but we have no clue why they would have thrown the bones into the crawlspace.

It was determined that the "whispering noises" had been caused by the ventilation duct. Someone in the bathroom talking in a normal tone can easily be heard in parts of the kitchen. It is more obvious when the restaurant is closed and equipment is shut off. The sounds are always there, but they are just more obscured when everything is on in the kitchen and the staff is busy. The noises coming from under the trapdoor were discovered to be loose pipes, as mentioned. To put it simply, there is no evidence to suggest that this location is haunted.

AFTERWORD

I hope you have enjoyed the ghostly tales of Old Town Albuquerque. Since there is only room in this book for the major stories, I have left out a few shorter ones for the casual visitor to explore. Additional photos, videos and audio files for many of the locations featured in this book can be found on the website of the Southwest Ghost Hunters Association (www.sgha.net), as well as in some rather interesting podcasts done by Ecto Radio (www.ectoradio.com). Although ghosts have not yet been proven to exist, the stories and folklore surrounding them can be quite entertaining in their own right. Just remember to walk with your mind wide open.

REFERENCES

Bottger Mansion of Old Town. bottger.com.

Church Street Café. churchstreetcafe.com.

Ecto Radio. ectoradio.com.

Garcez, Antonio. *Adobe Angels.* 1st ed. N.p.: Red Rabbit Press, 1994.

High Noon Restaurant and Saloon, Old Town Albuquerque, New Mexico. highnoonrestaurant.com.

La Placita Dining Rooms. laplacitadiningroom.com.

Library of Congress, Works Progress Administration historical records for New Mexico, Washington, D.C.

Metz, Judith. *Women of Faith and Service: The Sisters of Charity of Cincinnati.* Cincinnati, OH: Sisters of Charity of Cincinnati, 2009.

New Mexico History. newmexicohistory.org.

Southwest Ghost Hunters Association. sgha.net.

ABOUT THE AUTHOR

In 1985, Polston became the founder and president of a paranormal research and investigational team known as the Southwest Ghost Hunters Association (SGHA). Its mission statement, in keeping with the man himself, is to investigate all possible explanations of areas that are associated with reported paranormal activities. This is achieved by utilizing the scientific method of research and being open-minded to the results, regardless of one's personal belief structure.

He has appeared on numerous radio and television programs, including *Dead Famous* (Biography Channel), *Weird Travels* (Travel Channel) and *In Her Mother's Footsteps* (Lifetime Channel exclusive). He is the author of *Hunting the Ghost Hunters: An Introspective Guide to Ghost Research* and the co-author of *The Complete Ghost Hunter: Basic Methods to Advanced Techniques.*